Beginning
ACRYLIC

Tips and techniques for learning to paint in acrylic

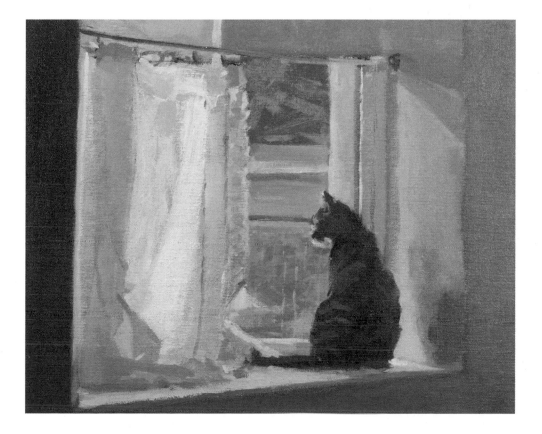

Walter Foster

Table of Contents

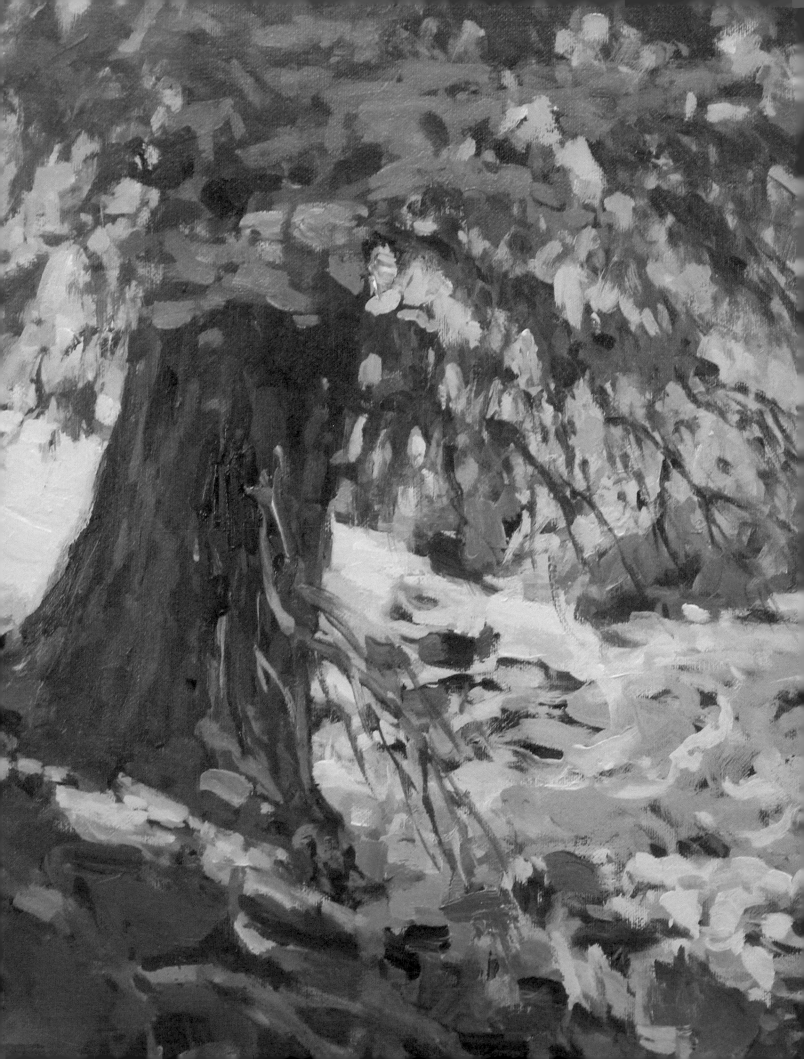

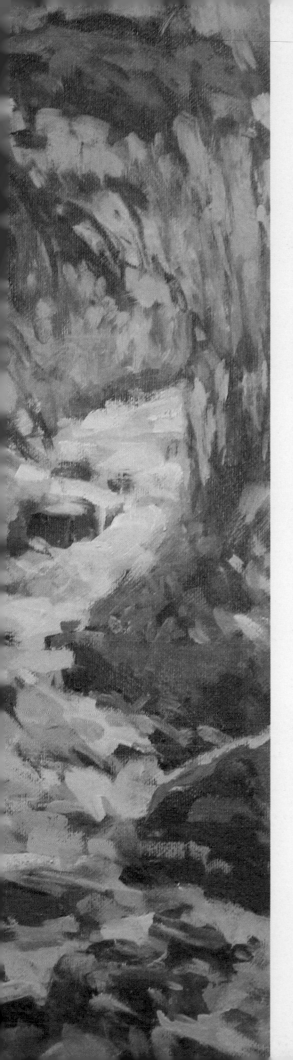

Introduction

So you are ready to start painting with acrylics. Fantastic! This book is a confidence-building guide to painting indoors and outdoors using a variety of techniques.

It's easy to get started. Gather some supplies, get organized, and follow the techniques and projects in this book to start building your own one-of-a-kind painting portfolio! The hands-on exercises and demonstrations are designed to pique your curiosity and empower you to accelerate your learning curve. In addition to developing internal awareness, I hope you will make it a practice to do something visually creative every day, even if you make just a small design or sketch.

Beginning Acrylic is intended to inspire and guide you, but remember that you are the ultimate apprentice, master, leader, student, teacher, and motivator of your artistic potential. You will gain confidence to enhance your life for the better in brilliant and beautiful ways. If you are kind, willing, patient, generous, forgiving, and trusting of yourself, your inner artist will appear!

GETTING

Started

Setting Up Your Studio Space

An effective art studio can be as simple as a desk or as grand as a dedicated room. As long as you have good light and ventilation, almost any area can serve as a studio.

FINDING THE RIGHT LIGHT

Your painting area needs a good light source that does not shine directly into your eyes. Natural, indirect daylight is ideal; direct light from windows can create a glare or shadow on your wet painting. Strong beams of light or shadows can make it hard to see what you're doing, and the light and shadow relationships will change constantly. Sheer curtains or waxed paper taped over a window work well to diffuse direct light.

When you need artificial light, be aware of the light's color temperature (see page 30). For example, incandescent bulbs cast a yellow tone that can negatively affect your painting. Choose a full-spectrum daylight bulb or compact fluorescent bulb to correct color temperature, and place it at a 45-degree angle to your easel or workspace. This will reduce glare.

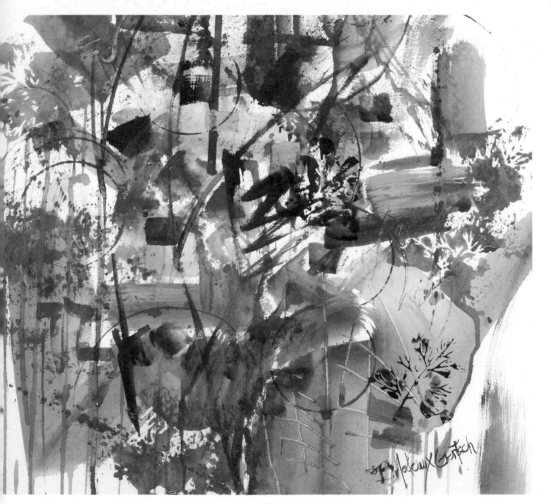

tip

MOVE AROUND WHILE SITTING, AND SWITCH TO A DIFFERENT CHAIR OR STOOL TO AVOID BACK STRAIN DURING LONGER PAINTING SESSIONS.

Painting with Acrylics

Acrylic paints are made from synthetic polymer emulsions mixed with organic or synthetic color pigments, plus water. The polymer emulsion acts as a carrier of the pigments, which can be manipulated with tools. Each pigment is mixed with a binder so that it can be applied to a surface. Additional water (more than a 1:1 ratio) will "break" the polymer bond and create a watercolorlike effect. This makes the paint less stable, however, so these paintings must be framed.

You can think of acrylics like liquid plastic. Usually acrylics can be mixed with water without damaging the polymer bond that adheres the pigment to the painting surface. When dry, or "cured," properly bound acrylics become water resistant, flexible, strong, and can be displayed without glass.

Acrylics are a relatively recent discovery in the world of art and are quite young compared to traditional mediums such as oil, watercolor, egg tempera, gouache, and ink. Today there is a dazzling array of colors, additives, and mediums with which to experiment. By adding specially designed mediums or additives, acrylics offer amazing options for creative expression and can be manipulated to mimic delicate watercolors, wax encaustics, or oil paintings. Using a range of tools, acrylics can be applied to many painting surfaces, such as paper, canvas, linen, plastic, glass, and even metal.

Acrylics are considered a fast-drying medium when compared with oils, but drying times vary with location, temperature, and humidity.

GETTING TO KNOW YOUR PAINTS

Acrylic paints come in tubes, tubs, jars, squeeze bottles, and jugs with pumps. Tubs, jugs, and squeeze bottles generally hold thinner paints, and traditional tubes contain thicker paints with more body. There are several different consistencies (or viscosities) of paint, from thick and heavily bodied to extremely fluid.

tips

NO MATTER WHAT CONTAINERS YOUR ACRYLIC PAINTS COME IN, MAKE SURE YOU KEEP THEIR OPENINGS AND LIDS CLEAN. IF YOU ALLOW PAINT TO BUILD UP, IT CAN GLUE THE LID SHUT. SMEAR A THIN COAT OF PETROLEUM JELLY ON LIDS FOR EASIER OPENING.

FLUID ACRYLICS

Fluid paint has a low viscosity, with a consistency between ink and basic acrylic paint. Fluid acrylics create a smooth finish and don't show brushstrokes or peaks. They can be used for staining and watercolor effects as well as airbrushing.

TUBE ACRYLICS

The most common acrylic used by artists has less viscosity than oil paint. Its consistency forms soft peaks and shows brushstrokes. It can be thinned with water or additives to create stains and watercolor effects, and it can be thickened using special mediums.

HEAVY-BODY ACRYLICS

This thick, buttery paint with a high viscosity retains brushstrokes and allows artists to form stiffer peaks of paint. It offers a great choice for highly textured work, such as what you can create with a palette knife or by using coarse brushstrokes and impasto techniques (see page 22).

tip

WITH ACRYLICS, YOU CAN DRIP, DRIZZLE, SPATTER, POUR, ROLL, SPREAD, SCRAPE, SPONGE, AND PILE ON YOUR PAINTS!

ACRYLIC INKS

The lowest viscosity of all acrylic paints, acrylic inks are permanent and high-chroma. They are used for pen drawing, staining, and watercolor techniques and for airbrush painting.

IRIDESCENT ACRYLICS

These paints feature a metallic shimmer. They are reflective and can add depth and surprising variations to a painting.

INTERFERENCE ACRYLICS

These transparent paints can shift between a bright, reflective sheen and its color complement. They work well when mixed with or glazed over dark colors and black.

tip ●●○

A BRUSH WITH WET PAINT ON IT WILL START TO HARDEN AS IT DRIES. TO AVOID THIS, THOROUGHLY RINSE EACH BRUSH BEFORE SWITCHING TO A DIFFERENT ONE. DON'T LEAVE YOUR BRUSHES SITTING IN WATER UNLESS THEY ARE SPECIFICALLY DESIGNED FOR THAT PURPOSE.

PAINTING TOOLS

Brushes come in a wide range of sizes, shapes, and materials. Their bristles can be made from animal hair and blends of natural and synthetic fibers.

FLAT BRUSHES are used for painting backgrounds, covering large areas, and blending. Large, stiff flats can move thick paint around a surface, while smaller sizes are essential for detailed and linear work.

BRIGHTS are short, squared-off brushes that are good for blending and making crisp lines and edges.

FILBERTS help maintain soft, rounded shapes and are ideal for blending and lifting color and maintaining soft edges.

ROUNDS taper to a soft point and are commonly used for detail and linear work.

FANS are used for blending paint and for creating textural effects like grasses.

MOPS carry a lot of water, so they are good for washes and watercolor techniques.

RIGGERS and **DAGGERS** make long, even lines.

SHORT HANDLES and **SMALLER BRUSHES** are convenient for close-up and tightly controlled work.

LONG HANDLES work well at a vertical easel, allowing the artist to maintain an overall view of the painting from a greater distance.

HOG BRISTLE BRUSHES lift and move stiffer paints and can maintain visible paint strokes.

SOFT ANIMAL-HAIR BRUSHES range from pony, squirrel, goat, and badger to very expensive sable hair.

SYNTHETIC BRUSHES can be very soft and are often used for fluid applications with no visible brushstrokes. The stiff types make distinct, visible strokes.

RUBBER-TIPPED BRUSHES and **RUBBER SHAPERS** allow the artist to push and pull the paint, creating interesting lines and textures.

tip

EXPERIMENT WITH AN INEXPENSIVE SET OF BRUSHES BEFORE UPGRADING.

Additional Ways to Apply Paint

PALETTE KNIVES have a flat shape and are generally used for mixing paint colors, but they can also apply paint to a surface. Painting knives are shaped like trowels and are used to apply paint as well. Some artists use palette knives exclusively, because the paint can be applied thickly. This produces a different look and texture than brushes do.

THESE TOOLS CAN ALSO BE USED TO APPLY PAINT. THEY ALL PRODUCE DIFFERENT EFFECTS, SO TRY THEM OUT FOR YOURSELF!

- Sponges
- Foam brushes
- Putty knives
- Cardboard strips
- Rubber stamps
- Toothbrushes
- Feathers
- Eyedroppers
- Cake-decorating tools
- Twigs and sticks
- Plastic forks

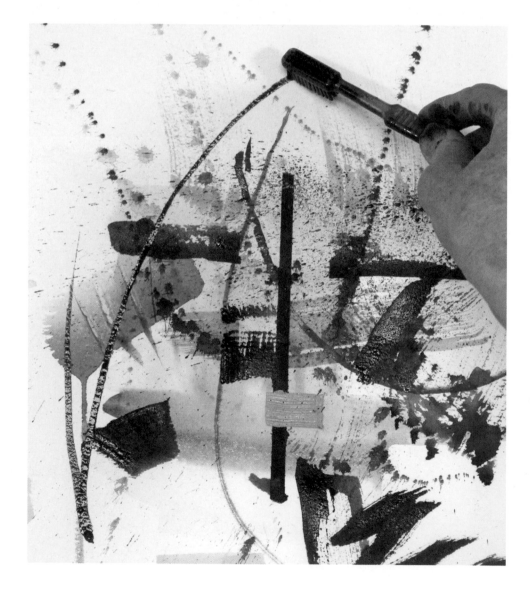

PAINTING SURFACES

Substrates can be any shape and size, but they are traditionally rectangular or square and may be thick or thin. Match your substrate to the acrylic painting technique that you are using.

THE EASE OF AN EASEL

Using an easel allows you to see your painting surface parallel to your eyes, eliminating the distortion of a flat-lying surface. When painting at an easel, step back from your work to see the overall subject from a slightly different point of view. This will refresh your perception.

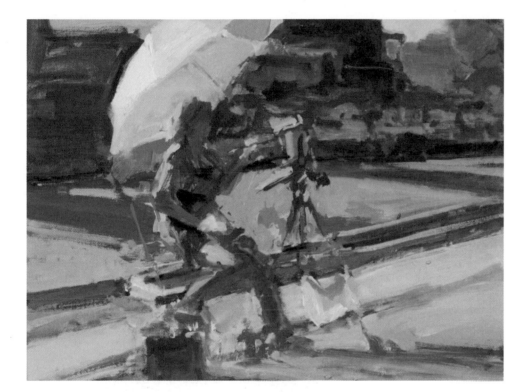

SURFACE OPTIONS

PAPER
Bristol board
Cardboard
Watercolor paper

CANVAS
Sheets
Panels
Stretched
Gallery wrap
Linen

OTHERS
Aluminum sheets
Plastic

IF YOU USE PAPER AS A SURFACE, TEST IT FIRST TO SEE HOW MUCH IT WARPS WHEN PAINT IS APPLIED.

USING WATER, ADDITIVES & MEDIUMS

WATER can be used to thin acrylic paint. Acrylics are waterborne and can be mixed with water in up to a 1:1 ratio without breaking the polymer bond.

ACRYLIC ADDITIVES change the behavior of paint without adding a binder. Usually you'll need just a small amount.

MEDIUMS alter the handling characteristics and appearance of acrylic paint, making it easier to work with. They can be applied to a painting surface first, and they can also be mixed with acrylic paint in any ratio, because they are made of the same polymer materials as acrylic paints. Some mediums maintain the intensity of the original paint color, while others lighten the paint's intensity. Specialty textural mediums bulk up the paint, adding dimension to the painting surface. Some mediums can change the flow and thickness of paint or alter its sheen, while still others change certain paint characteristics such as hardness or flexibility. Mediums can usually be mixed together to create unique results. Specialty gels can be mixed with color or applied before paint to create texture, such as a slightly raised relief.

PASTES can be applied to a substrate to enhance a textured surface, or they can smooth a rough surface before painting.

RETARDERS are additives that slow the drying time of acrylic paint. Acrylic paint dries quickly, so artists use retarders to extend their working time and blend more easily.

FLOW IMPROVER is a liquid additive that increases paint's fluidity by breaking the surface tension. It also helps preserve the intensity of a paint color.

GEL has the same viscosity as pure acrylic paint. Adding gel extends a color's volume, giving you more paint to work with. It also adds texture and body to paint.

WORKING WITH SEALANT & VARNISH

SEALANT is a barrier coating applied to a finished painting prior to varnish. A sealant allows varnish to be removed and reapplied later without disturbing the original paint layer, and it helps coat the porous paint surface, allowing for a uniform application of varnish.

VARNISH is the final protective coat for a finished painting. It makes cleaning a painting much easier, and it provides an even sheen to remedy dull spots or shiny areas.

GEL LOOKS CLOUDY WHEN WET, BUT IT DRIES TO A CLEAR FINISH.

tip

THE BEST WAY TO HANDLE GELS AND PASTES IS WITH A PALETTE OR PAINTING KNIFE. USE THE KNIFE TO SCOOP OUT THE MEDIUM, MIX IT WITH YOUR PAINT, OR SPREAD IT OVER YOUR PAINTING SURFACE.

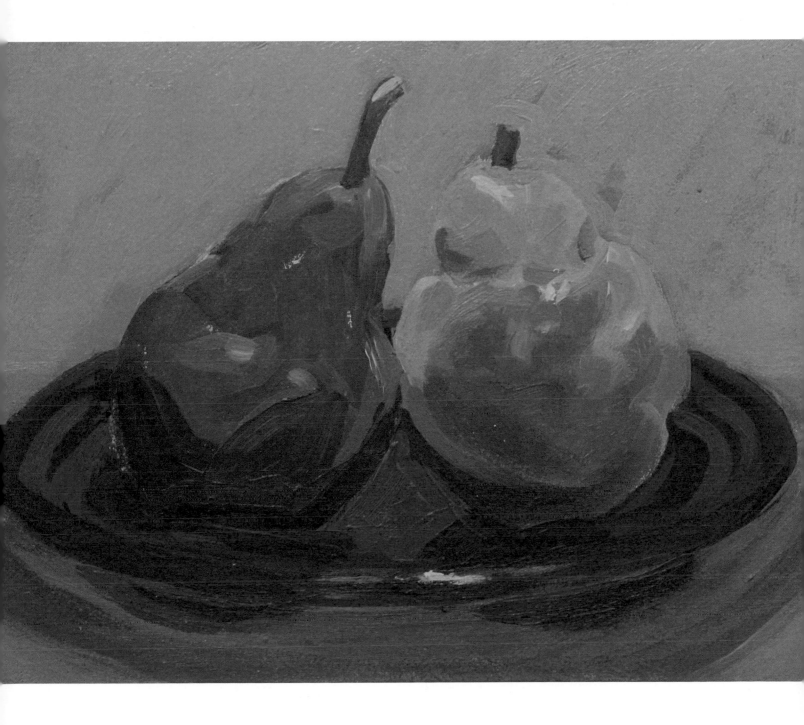

Making Your Mark

Acrylic paint works well for experimenting with both watercolor and oil-painting techniques. Brushstrokes can vary in thickness, texture, width, and direction. Here are some common techniques and examples of what they look like.

WET-INTO-WET: Very diluted paint that creates a random blend of colors and soft edges. This technique can be used to enhance large areas, such as skies and bodies of water.

WET-ON-DRY:
Brushstrokes maintain their crisp edges when wet color is applied to an unpainted surface or over previously painted, dried areas.

DRYBRUSHING: Load your brush with paint, and then dab it on a paper towel to remove the excess paint. This leaves speckled, broken strokes when applied to a surface. It works best with a light touch that just skims the surface. A mop brush works well for this technique.

tip

BEFORE SPATTERING, USE A SHEET OF PAPER TO COVER ANY AREA THAT YOU DON'T WANT PAINT ON.

SPATTERING: Use a paintbrush to fling or spatter. For more control, tap the paintbrush on your finger to fling the paint, or run a fingertip over the bristles to spray the paint.

A toothbrush can create a spattering effect as well.

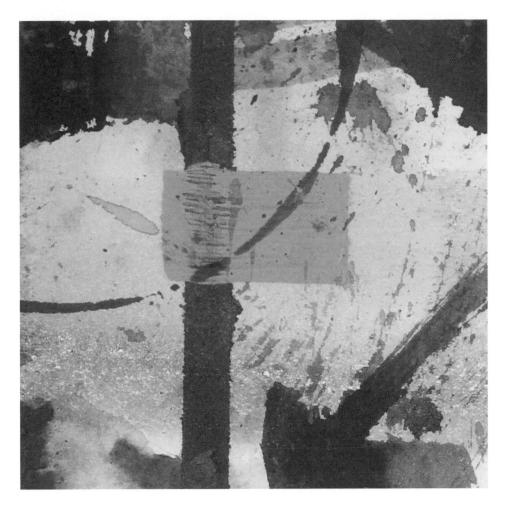

MASKING:
Use masking tape to form a shape such as this rectangle, brush thick opaque paint over it, and let it dry. Then remove the tape to create clean edges or mask out areas that should stay free of paint.

SPONGING: Load one side of a sponge with paint, and swipe it across the page. Experiment with various transparent or opaque layers applied over each other.

MORE TECHNIQUES

FLAT WASH: Thin your paint with water, and stroke it evenly across your surface. Mixing wash and drybrush methods creates an exciting variety of textures in one piece.

GLAZE: Apply a thin layer of acrylic over another to mix the colors.

SCUMBLE: Drag a brush loaded with paint over an area using a light touch.

STIPPLE: Small, closely placed dots of paint.

IMPASTO: Building thick layers of paint.

GRADUATED BLEND: Create a gradual blend of one color into another by stroking two different colors horizontally on a canvas and leaving a small gap between them. Then continue to stroke horizontally, working downward with each stroke to pull one color into the next. Retrace your strokes if necessary to create a smooth blend between the colors.

DAB: Use press-and-lift motions to apply irregular dabs of paint. This is great for creating foliage and flowers.

SCRAPE: Create designs by scraping away paint. With the tip of a painting knife or the end of a brush handle, scratch in the paint to remove it.

WIPE AWAY: With a rag or paper towel, wipe away wet paint. Use this technique to remove mistakes or create a design.

MAKE AN ABSTRACT PAINTING USING EVERY TECHNIQUE YOU CAN THINK OF LIKE I DID HERE!

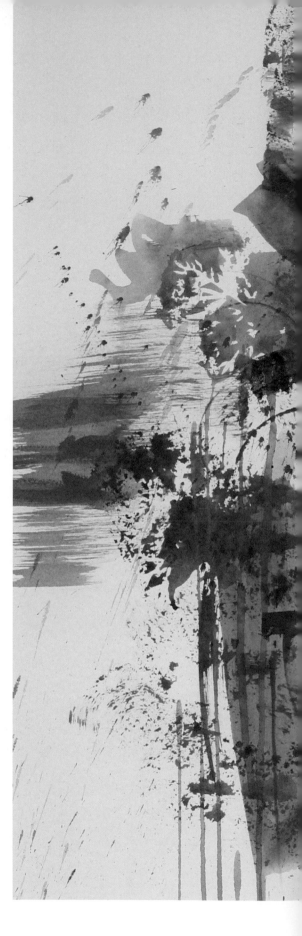

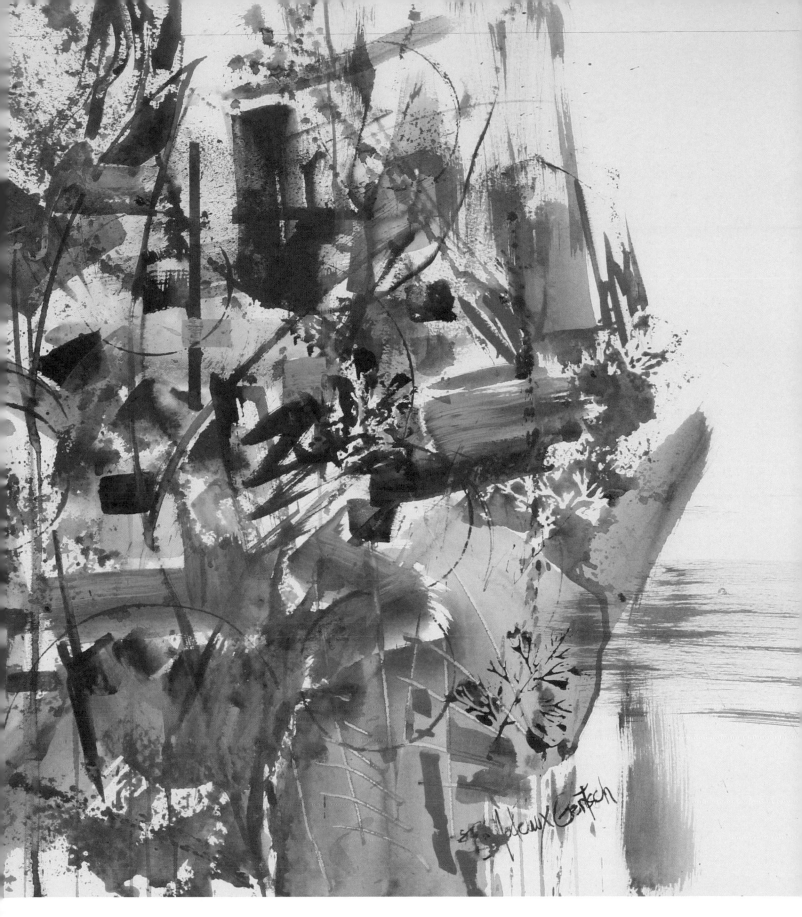

Which techniques can you identify in this piece?

The Color Wheel

The color wheel is the most useful tool for understanding color theory and harmonies. Where the colors lie relative to one another can help you group harmonious colors and pair contrasting colors to communicate mood or emphasize your message. The wheel can also help you mix colors efficiently.

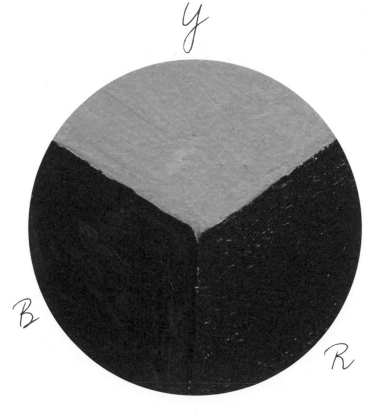

EXERCISE IN COLOR

Creating a simple diagram will help you learn color-mixing relationships. First, draw a triangle. Mark the letter "Y" (yellow) above the top point, "R" (red) at the right corner, and "B" (blue) at the left corner. These are the **primary colors**.

Layer this triangle with an upside-down triangle to make a kind of star shape, with "O" (orange) at the upper-right corner, "V" (violet) at the lower-middle corner, and "G" (green) at the upper-left corner. These are the **secondary colors**.

Create a third layer by adding a dot between each primary and secondary color. Draw a half-circle from point to point around the six triangles. Next to each half-circle, mark the following letters, beginning to the right of "Y": "YO" (yellow-orange), "RO" (red-orange), "RV" (red-violet), "BV" (blue-violet), "BG" (blue-green), and "YG" (yellow-green). These are the **intermediate colors** or **tertiary colors**.

Memorize this simple diagram, and practice drawing it so you grasp color relationships and their potential for mixing colors.

Color Schemes

Certain color combinations are considered especially agreeable. They consist of two or more colors with a fixed relationship on the color wheel. The following color schemes are most commonly used as a basis for a beautiful painting.

A color without chromatic content is **achromatic**. Pure achromatic colors include black, white, and gray.

A **monochromatic** color scheme features a variation on values (light and dark) and saturation of a single color. Monochromatic colors allow a painter to focus on values. They can be used to establish a mood or integrated with neutral colors, such as black, white, and gray.

Primary colors are red, yellow, and blue. They cannot be mixed from other colors, but all colors can be mixed from them. **Secondary colors** (green, orange, and purple) are created by mixing two primary colors. **Tertiary** colors consist of a combination of one primary and one secondary color.

A **triadic** color scheme uses colors evenly spaced around the color wheel, such as the three primary colors. Triadic color schemes look vibrant and offer strong contrast and richness. A triadic color scheme should be balanced and let one color dominate while using the other two as accents.

Analogous color schemes use three or four colors that sit next to each other on the color wheel. One color is used as a dominant color, with the others subordinate. An analogous color scheme is naturally harmonious.

Complementary colors are two colors that sit opposite each other on the color wheel. Placing complements directly next to each other in a painting creates a strong, vibrant contrast. Mixing them in different amounts reduces their color intensity (saturation). When mixed equally, complementary colors reach an earthy tone related to brown or gray.

ABOUT BLACK & WHITE

Black can muddy colors. Instead of using **black**, trying using the darkest possible mixture of primary colors. **White** cools colors, so you may need to add a little bit of a warm color to balance it out. White also has a tendency to make colors "chalky." To avoid this, mix colors first, and then add white as needed.

Simplifying Color Theory

By now, you're probably getting antsy and just want to paint. Don't forget about color theory, though! Color plays an important role in the mood and feel of a painting, and it can elicit various emotions.

COLOR BASICS

Let's start with some important characteristics of color.

- **HUE:** a color in its purest form
- **VALUE:** the lightness or darkness of a color or black
- **SATURATION:** the level of a color's intensity or dullness
- **TEMPERATURE:** the feeling one gets when viewing a color or set of colors
- **TINT:** a color plus white
- **TONE:** a color plus gray
- **SHADE:** a color plus black

COLOR & VALUE

Value is the lightness or darkness of a given color. When colors are photographed in black and white, yellow is closest to white, and violet registers as closest to black.

It's useful to practice painting in black, white, and gray from time to time. This will train the brain to perceive the value of each color in a subject.

tip

CREATE A VALUE SCALE WITH 10 SEGMENTS. THE MIDDLE SEGMENT WILL BE A NEUTRAL GRAY, AND THE CONTRASTING COLORS OF BLACK AND WHITE WILL BE AT EITHER END.

WARM OR COOL?

We make either warm or cool associations with colors. Warm colors include yellows, oranges, and reds; cool colors are blues, greens, and violets. A color's temperature relates to the colors around it. This is important to remember when suggesting depth or creating the illusion of a three-dimensional form.

Compare these two examples below. They are the same photograph, but the color temperatures have been altered.

WARM COLORS SEEM TO ADVANCE TOWARD THE VIEWER, AND COOL COLORS APPEAR TO RECEDE INTO THE DISTANCE.

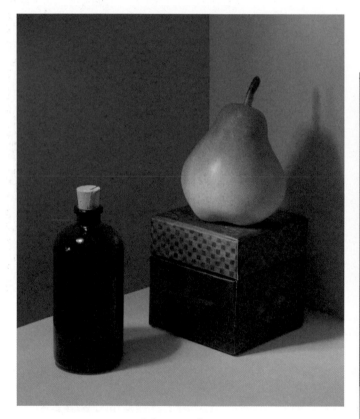

Warm colors

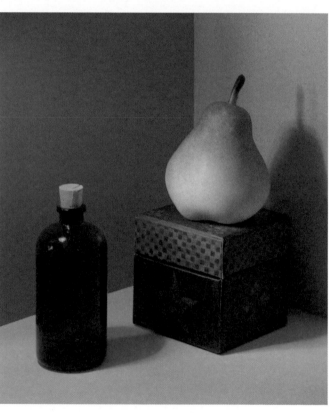

Cool colors

COLOR INTENSITY

Chroma is the intensity of a color. You can change a color's chroma by creating a tint (add white), tone (add gray), or shade (add black). You can also change the chroma by adding some of a color's complement, such as adding orange to blue, red to green, or yellow to violet.

Likewise, the chroma of secondary and tertiary color mixes depends mostly on how your paints relate to one another on the color wheel. For the most vibrant (high-chroma) mixes, mix two colors that lean toward each other on the color wheel. For muted (low-chroma) mixes, mix two colors that lean away from each other on the wheel.

tip

IT'S A GOOD IDEA TO LIMIT THE NUMBER OF PAINTS YOU MIX TOGETHER. A COLOR CAN BECOME MUDDY OR DULLED IF THERE ARE TOO MANY PIGMENTS PRESENT.

Picking the Perfect Palette

These 10 colors are a good basic palette for acrylic painting. Like any basic palette, this one includes a warm and cool version of each of the primary colors. Although you can mix a wide range of colors using this palette, you'll probably want to add certain colors based on your personal preferences.

- Ultramarine or cobalt blue
- Phthalo blue
- Alizarin crimson
- Cadmium red
- Cadmium yellow medium
- Dioxazine purple
- Lemon yellow
- Burnt umber
- Titanium white
- Ivory black

tip

ART-SUPPLY STORES SELL SPINNING, HANDHELD COLOR WHEELS THAT YOU CAN USE AS A COLOR-MIXING GUIDE.

When choosing a palette or a color scheme, focus on choosing colors that will help convey your desired mood. For example, yellow is a cheerful color that often means warmth, happiness, hope, and positivity. Red conveys energy, power, passion, and love. Pink represents femininity, love, and romance and is thought to have a calming effect. Purple conveys elegance, dignity, and sophistication. Green symbolizes freshness and harmony. This painting uses all of these colors—and more! Notice that the intense, high-chroma colors are balanced by neutrals mixed from complementary colors.

Drawing Techniques

Use drawing media and a sketchbook as fast, effective tools for planning your acrylic paintings. Small thumbnail sketches in graphite or charcoal will help you familiarize yourself with your subjects. With a little practice, a sketch can be done very quickly.

Drawing marks can be continuous or broken, straight, curved, zigzag, or undulating and can give a design vertical, horizontal, or diagonal direction. Build layers of marks to create value gradations and the illusion of form with light areas, shadow forms, cast shadows, and reflected lights. The greater the contrast between light and dark, the more realistic the three-dimensional form and space will be.

A reference photo will help you create a useful sketch of your subject.

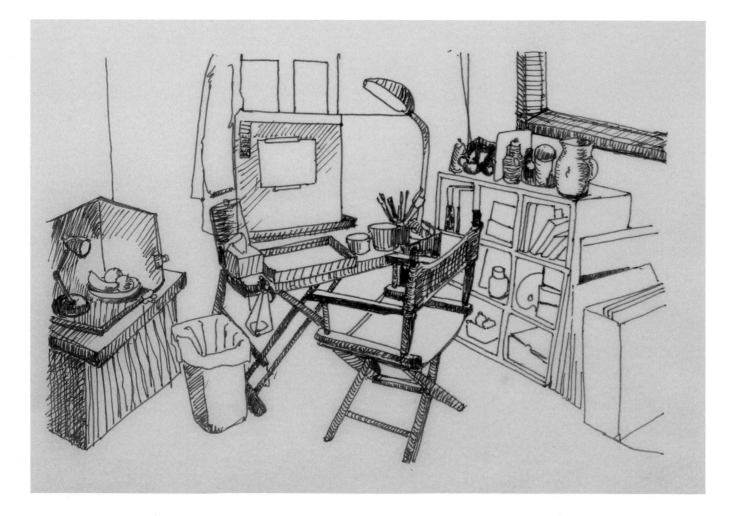

DRAWING EXERCISES

THESE EXERCISES WILL HELP YOU RAPIDLY IMPROVE YOUR PAINTING SKILLS.

1. Sketch daily.

2. Make daily quick-draw designs using pencil, ink, markers, or other drawing media and images from magazines or the Internet.

3. Make stipple drawings.

4. Create loose- and free-scribble drawings like this one.

5. Do blind contour drawings. Keep your eyes on the subject as you draw!

6. Turn a reference photo upside down, and draw from that. This will help you focus on the shapes in the photo.

7. Draw the negative space in or around a subject first, and the subject will appear.

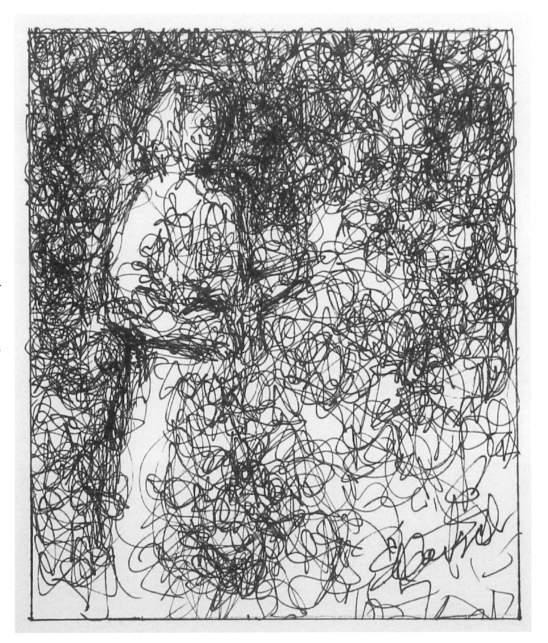

SKETCHBOOK JOURNAL PORTFOLIO

Your sketchbook is where you'll work out the design and values of a painting before you create it. It's also a great place for daily drawing exercises that will sharpen your hand and eye skills and allow you to experiment with subject matter and drawing media.

Keep small color samples and textural experiments made with different acrylic mediums and papers for future reference. A really good sketchbook will reflect your personal notes, thoughts, feelings, and ideas. Many artists take them everywhere they go.

tip

USE A DIGITAL TIMER TO LIMIT YOUR SKETCHING TIME.

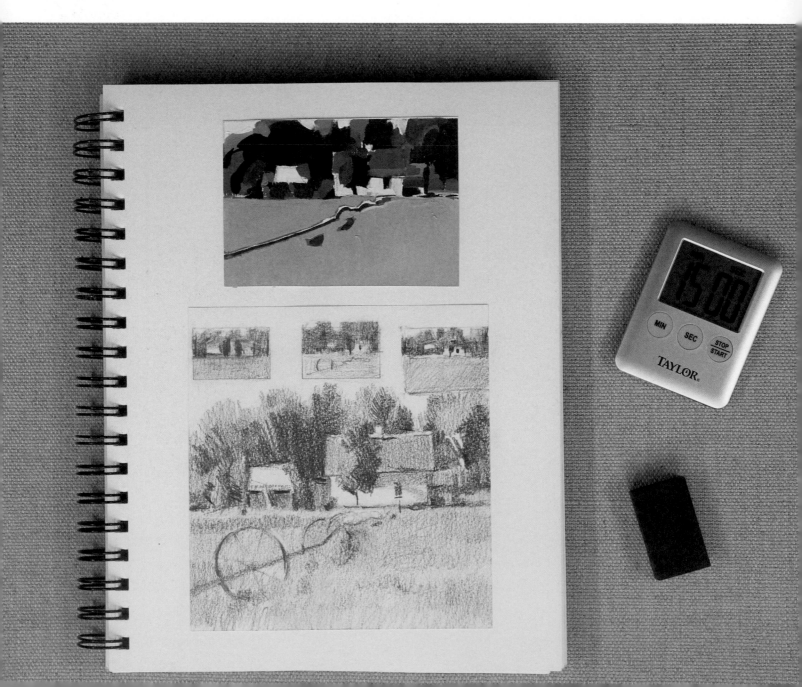

LIGHT & SHADOW

An artist must understand and recognize how light and shadow create form and depth. Drawing daily, even for short periods of time, will provide the best training. The more you notice the light logic of your subject, the easier it will be for you to create a sense of realism in your art. With practice, you can develop a good eye for seeing lights, darks, and the subtle transitions between each value across a 3D form.

THE FIVE MAIN VALUES TO LOOK FOR ON AN OBJECT ARE THE CAST SHADOW, CORE SHADOW, MIDTONE, REFLECTED LIGHT, AND HIGHLIGHT (SEE PAGE 38 FOR MORE ON ALL OF THESE).

SOME IMPORTANT TERMS

FORM SHADOW: The dark side on an object not facing the light source.

CAST SHADOW: A shadow created on a form next to a surface that is turned away from a light source.

CORE SHADOW: The darkest value on an object, which is located on the side opposite from the light source.

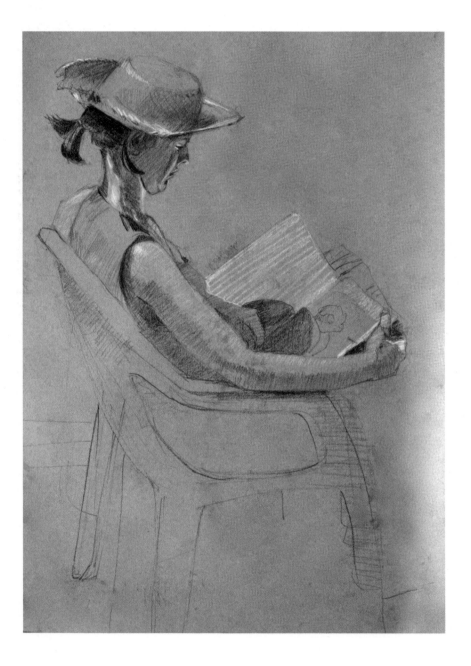

MIDTONE: A middle-range value located where the surface turns from the light source.

REFLECTED LIGHT: A light area within a shadow that comes from light reflected off of a different surface nearby.

HIGHLIGHT: The area that receives direct light.

USING A STILL-LIFE STAGE

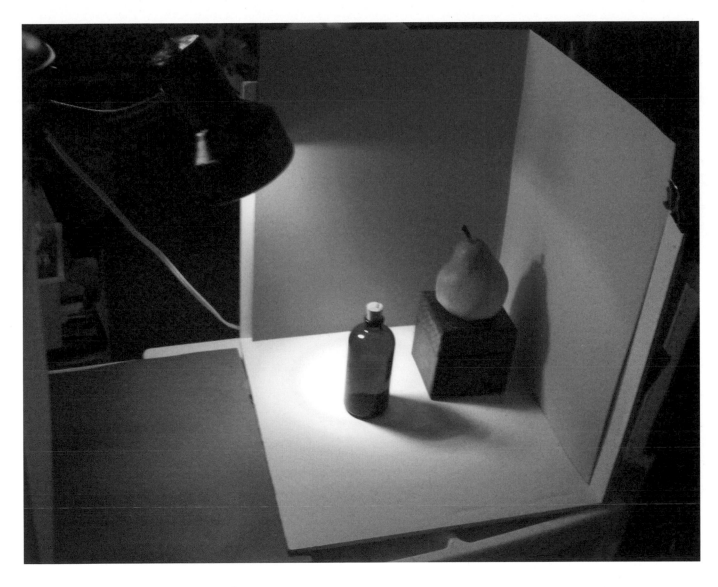

A still-life stage gives you a perfect, miniature theatrical set with which to study the results of dramatic light and shadow on real objects. It also allows you to work at any time of day, regardless of the light outside. The idea here is to create a light-controlled environment that can be illuminated by a small desk lamp shining on your still-life objects. You will need a box with four sides, a piece of cardboard or cloth to cover the top, and a small desk lamp. Placing the lamp on either side of your subject(s) allows you to see its strongly lit side as well as its contrasting shadowed side.

NOTICE THE SHADOWS CREATED WHEN YOU SHINE A LIGHT ON OBJECTS IN A STILL-LIFE STAGE.

THE
Elements
OF ART

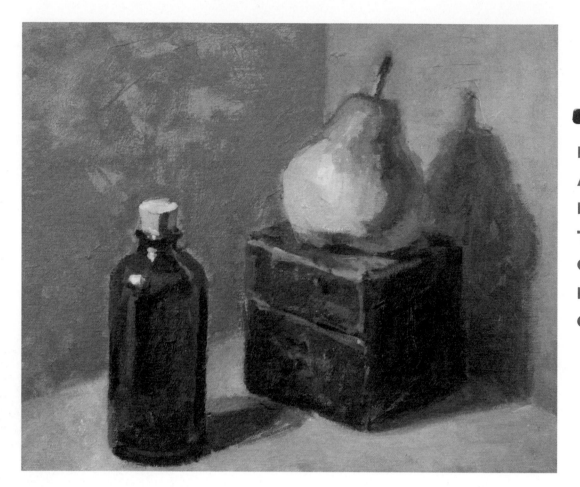

EVERY
ART FORM
FEATURES
THE ELEMENTS
OF ART AND
PRINCIPLES
OF DESIGN.

INTRODUCTION

Imagine yourself biting into a juicy lemon. You may or may not like it, but it will leave an impression either way. Then picture yourself eating a slice of dry, stale bread. You'll probably dismiss it as bland and unappetizing. Now contrast that with a generous serving of your all-time favorite food. It will stir complex sensations that you'll remember with pleasure long after you've consumed the food.

Experiencing a work of art can produce sensations in your mind and emotions that are just as varied and even more (or less) appetizing than food. Some paintings look bland, boring, and unmemorable, while others are interesting, energizing, and visually delicious. As the painter-creator, you will decide what to serve yourself and your viewing audience each time you paint. What is the '"recipe" for creating an interesting, delicious painting?

The answer is a good concept, design, and technique. In design, some essential aspects are present every time you create a work of art: the elements of art (line, shape, value, color, texture, form, and space) and the principles of design (balance, harmony, rhythm, repetition, variety, emphasis, scale, and dominance). Every art form features elements of design, and no art form exists without them.

"ART CANNOT BE SEPARATED FROM LIFE. IT IS THE EXPRESSION OF THE GREATEST NEED OF WHICH LIFE IS CAPABLE, AND WE VALUE ART NOT BECAUSE OF THE SKILLED PRODUCT, BUT BECAUSE OF ITS REVELATION OF A LIFE'S EXPERIENCE."

—Robert Henri, American painter

THE FINISHED DESIGN

A finished composition (your painting) is essentially an organized space. It presents the viewer with your message, ideas, and feelings. Visual art is a form of nonverbal communication. That universally understood communication is what makes art so important to us all.

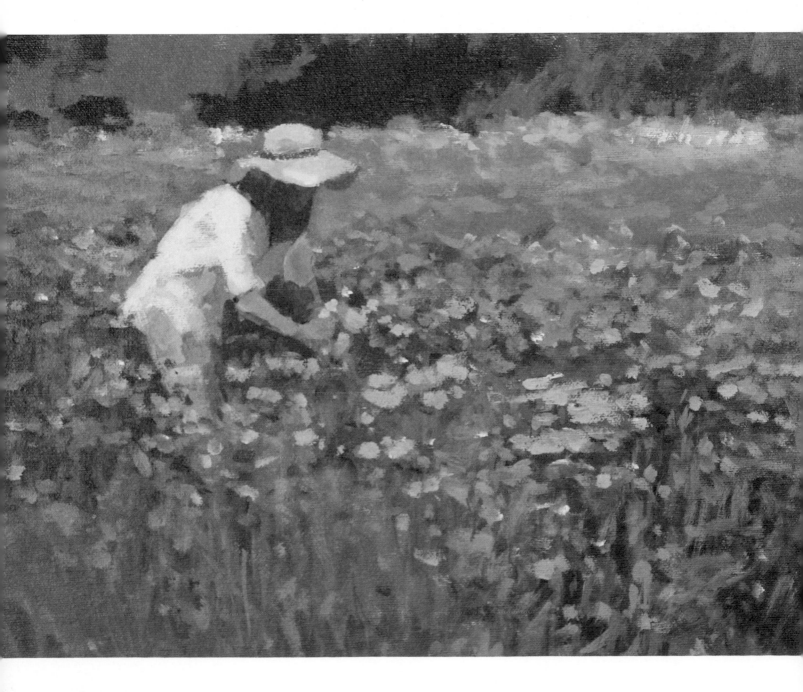

7 Important Elements of Art

1 Lines are essentially long marks. Lines vary in length, thickness, and direction. They can be broken, geometric, organic, straight, curved, or zigzag; they can be implied by spaces between objects; and they can be layered until they form masses of value and tone.

2 Shapes are enclosed spaces. The basic shapes are a circle, a triangle, and a square. All other shapes are a variation or combination of these three. Shapes can be geometric, organic, or a combination.

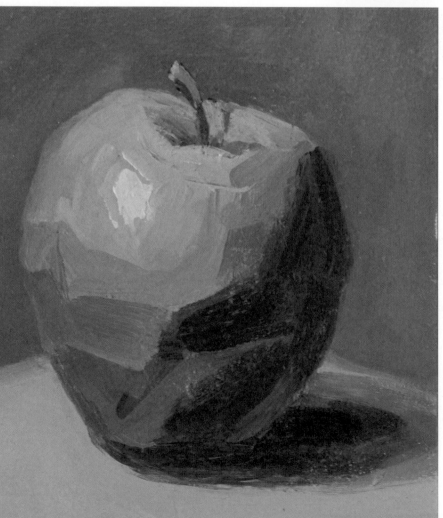

3 As mentioned on page 28, **value** refers to the relative lightness or darkness of a color. Shapes would remain flat without the gradations of light to dark values.

4 Color refers to the perception of light waves by the brain that reflect into our eyes. A **hue** is a color in its purest form.

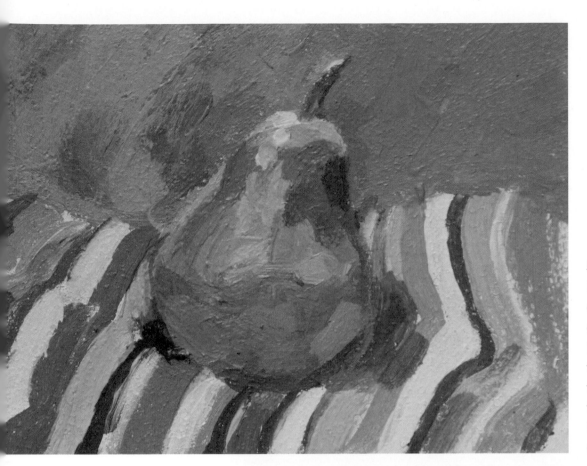

5 Texture is the literal sensation experienced when an object's surface is touched. Implied texture exists when the visual illusion of that surface quality is created by art elements.

6 & 7 Form and **space** refer to the illusion of 3D objects in drawings or paintings using line, shape, value, and color. The areas around and within shapes are called "negative spaces."

8 Important Principles of Design

A well-designed, successful painting features many of these elements. How these principles are applied affects the message of a work.

1 Repetition: a predictable interval of elements (lines, shapes, values, colors, or textures).

2 Variety: the diversity of elements or a shift in a repeated element.

3 Contrast: the relative difference between two or more elements of art.

4 Emphasis: a noticeable difference or dominance of one or more elements.

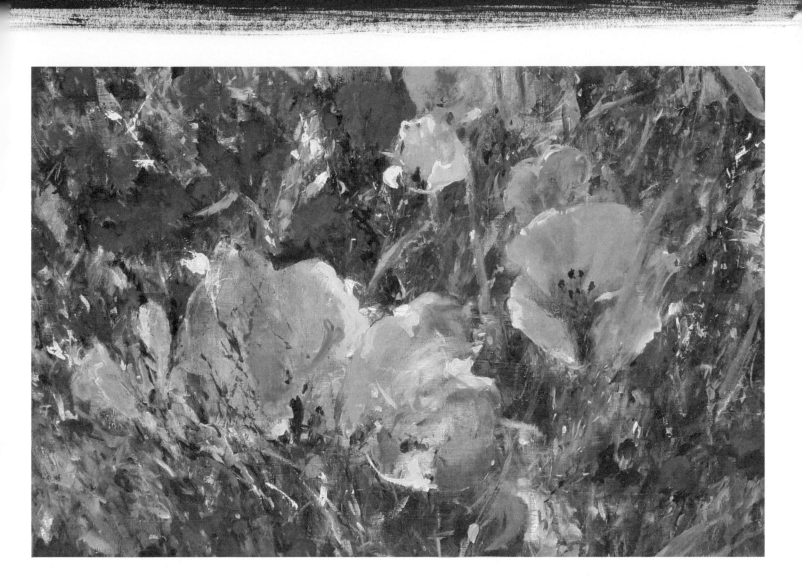

5 Balance: the concept of visual equilibrium. Compositions can achieve balance symmetrically or asymmetrically.

6 Proportion: the relative size, shape, and volume differences of one art element or object relative to another.

7 Harmony and unity: the sensation of wholeness or stability perceived in the work as a whole.

8 Rhythm: the sensation of movement created by the repetition and sequence of art elements.

Design Tips

These helpful hints will help you understand composition and create a harmonious, interesting painting.

- Locate the focal point (where you want your viewers' eyes to go) on your format (the shape of the painting surface).

- Divide shapes or spaces into thirds rather than in half. The unequal division generally looks more interesting, just as odd numbers of objects, shapes, and spaces create more visual interest than even numbers.

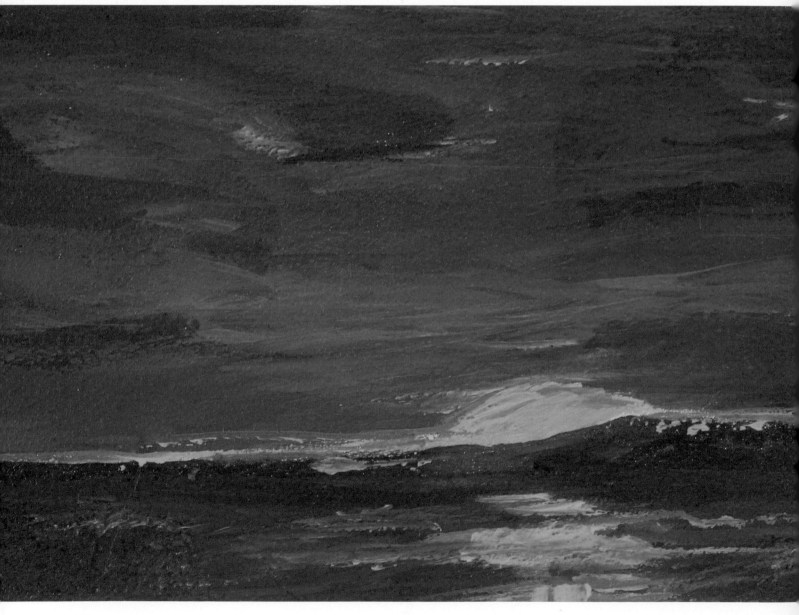

- Repetition with variety maintains interest, harmony, and unity.

- Avoid placing the focal point in the exact center of the picture plane. This can create a bull's-eye effect that can feel static.

- Avoid painting strong diagonal lines, such as roads or streams, that move directly into the corners of the format, because this directs the viewer's eye *out* of the painting rather than *into* the painting.

- Overlap shapes or increase the space between them. Don't place them so they barely touch each other; this creates an awkward visual tension. A V-shaped point can become an eye trap when it slightly touches another shape or the sides of the format.

Still Life with Simple Shapes

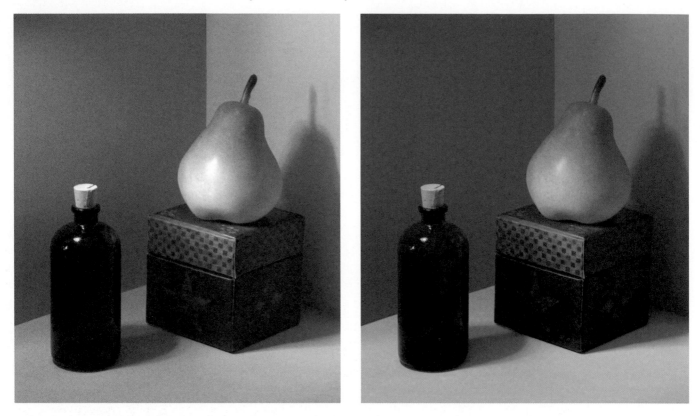

Light; composition; relationships in values, colors, and textures; and context can make simple objects visually beautiful. Here you'll work with the seven important elements of art (see page 44) as well as the principles of design (page 46) to paint a simple still life.

You can arrange the objects however you like to find the most interesting light and shadow patterns. Uneven divisions of space make even a simple scene look interesting.

RENDERING IN VALUES

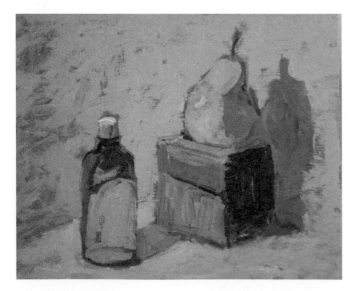

Two-dimensional shapes: Roughly sketch a circle, a square, and a rectangle in black, white, and gray to indicate initial values.

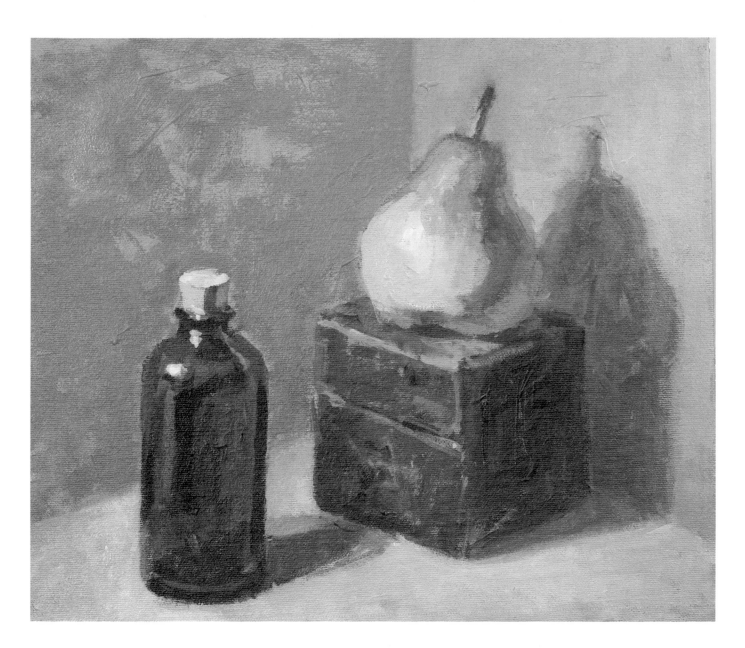

Develop the two-dimensional shapes with light and dark values into a sphere, a cube, and a cylinder to create the illusion of three-dimensional form.

The little brown bottle is made up of a half-sphere combined with two cylinders: one at the neck of the bottle and one at the base. The pear is also a combination of basic shapes: a cylinder between a small sphere at the top and large spheres bulging at the base.

ADDING COLOR

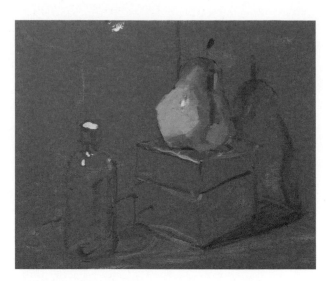

The initial sketch lays out the division of space, the placement of the objects, and the relationship between the subject and the format. Highlights on the two main objects are noted in white.

tip

TONING THE CANVAS WITH BRIGHT ORANGE PAINT MEANS THE REST OF THE OBJECTS WILL LOOK COOLER, BUT THE OVERALL EFFECT WILL STILL BE WARM.

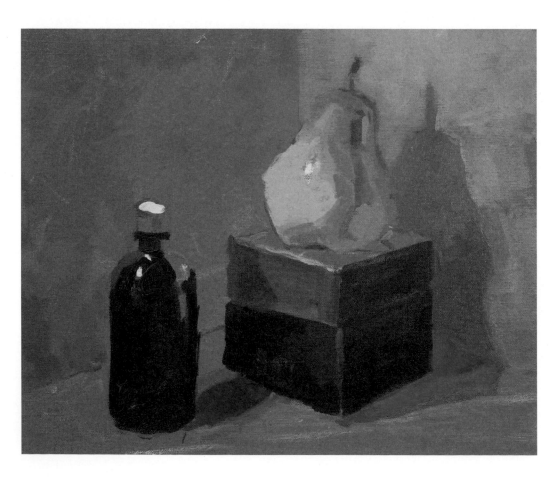

Block in the darkest darks. All other values will be relative to these extremes. Next block in the shadows cast on the wall by the pear and the box. Keep the edges soft to avoid abruptly directing the eye to that part of the painting.

Now block in the shadows cast by all three objects, whether they're on the table or the right wall. The bottle's cast shadow creates an interesting shape and connects the objects in a design relationship.

Block in the tabletop. The green tone creates beautiful negative shapes around the objects.

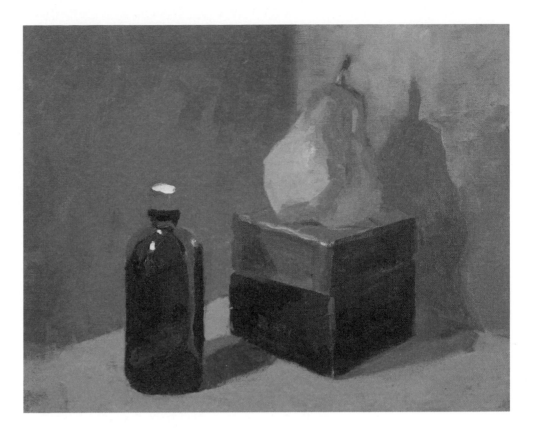

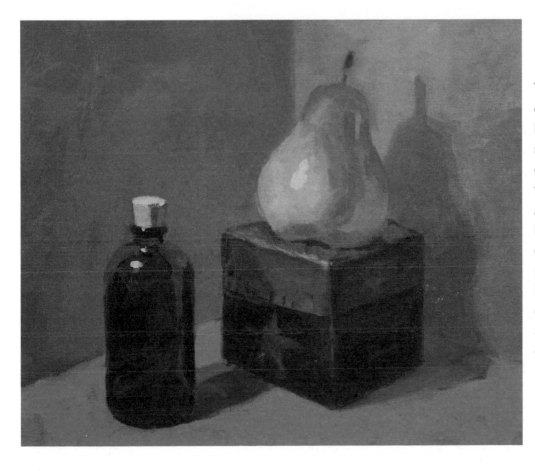

You can reduce the color intensity on the left wall by adding small amounts of green and yellow to the orange base color. Add texture with loose brushwork dragged over the surface of the painting. Reflected lights in the pear and on the top of the box serve as dynamic accents.

PLEIN AIR
Painting

Setting Up

Plein air painting promises an exciting change of pace from work, stress, and life's daily routines. Hikers, bikers, and world travelers have found ways to pack ultra-light gear for plein air sessions at home and abroad. Buyers are interested too, so for those seeking to sell their paintings online or at plein air events, you can earn while you learn!

I can personally vouch for the positive, healthful, and exciting benefits of plein air painting, having completed 300 paintings *en plein air* in one year. This fully authentic on-location experience is very different from the predictable, controlled comforts and conveniences of an indoor studio. Variables and challenges such as inclement weather only become a problem if you are unprepared. Plan ahead, and you won't be intimidated by possible changes in weather.

You can choose an interesting-looking busy street, or set up right in your own backyard. You may opt to paint solo just for the joy of spending time in nature, or you can take a friend along or join a plein air group. Each situation will create a different kind of experience for you, so try them all!

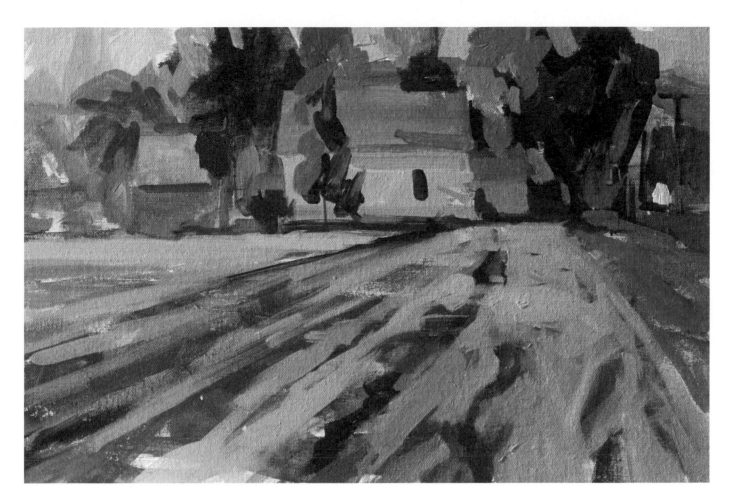

GEAR

Plein air painting requires nearly the same equipment as painting indoors, but with a few deletions and some important additions. It's wise to keep your gear trimmed down to the essentials.

What you'll need:

- A box, bag, or case to carry your gear
- Water
- Brush-washing bucket and a container for clean water
- Paper towels
- Painter's tape and duct tape
- Your preferred painting surface
- Brushes

- Palette and painting knives
- Spray bottle
- Craft box with compartments pre-filled with acrylic paints
- Sketchbook and pencils
- Easel
- Umbrella for shade (since the sun is your light source)
- Palette
- Wet paint carrier

PLEIN AIR PROCESS

Take in the scene, and consider the possible views for your composition. Also think about the direction of the light source. Early morning light and late-afternoon light usually look most dramatic. Midday light is nearly straight overhead, so the shadows disappear and tend to make forms look flatter. Give yourself about two to three hours before the sun and shadows significantly change the scene. Consider the design tips on pages 48-49, and think about where to place the horizon line on your composition. Then tone your canvas, and let it dry while you spend about 5 to 10 minutes doing preliminary sketches in pencil or charcoal. Your sketches should reduce the complexities and details in your subjects to simple shapes and patterns.

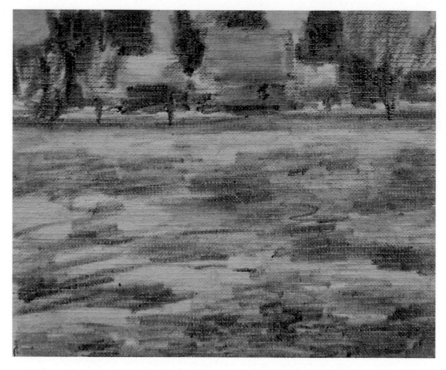

Quick sketches help you simplify a scene and capture its basic shapes.

REFINING THE SUBJECT

Look at your scene or subject frequently, and occasionally spritz your palette with water as you paint. Keeping acrylic paints wet and workable is essential. But don't overwater the paint!

tip

KEEP CLIPS AND TAPE HANDY FOR HOLDING DOWN LOOSE PAGES OF YOUR SKETCHBOOK WHILE YOU WORK OUTSIDE.

MORE TIPS FOR
TAKING IT OUTSIDE

Once you're ready to paint outside, follow the process on page 58, and consider these additional helpful hints.

WHERE TO PAINT: Research locations beforehand so you know where you want to paint and where to set up your gear. You can paint anywhere you like, from an exotic location to a park to a friend's garden. Wherever you go, keep in mind that you'll want to be comfortable while you paint, so you may want to opt for a location that's shaded and out of the wind. If that's not possible, use an umbrella for shade.

TAKING IT BACK INSIDE: Some might say that you should start and finish your painting outdoors, but that isn't always possible. Start by sketching out the whole painting, and add its main elements while the light and weather remain workable. Then add the essential details. You can go back inside and finish your painting if the weather changes.

KEEP YOUR COLORS SIMPLE:
Bring just a few paint colors with you to paint outdoors. Fewer colors usually produce a more harmonious result, and you can mix up certain colors, like greens, if you need more than what you've brought.

WHAT TO WEAR: Wear neutral colors that won't reflect on your painting, and leave the sunglasses at home. Sunglasses can affect how you see colors, so try wearing a hat in bright sunlight instead.

tip

WORK IN LAYERS, AND USE A LIGHT TOUCH.
THIS WAY, YOU WON'T CREATE MUD ON THE PAGE.

IN OPEN AIR

Now it's time to put your design skills into plein air practice. Remember that *"en plein air"* means to paint "in the open air." Artists are encouraged to get outside and paint rather than painting from a photograph, although it's fine to do so. You can also head outdoors to take a photo or do a quick sketch before going back inside to paint and using the photo to add details. It's up to you! Here I've painted a springtime scene. Bring these pages outside for a real plein air experience, or try recreating this painting before coming up with your own.

Use scribbles and draw loosely to sketch the house and the horizon. This sketch should be energetic and fun!

An initial layer of green goes on easily.

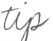

COMMERCIAL LINEN COATED WITH CLEAR PRIMER DOESN'T REQUIRE AN INITIAL WASH.

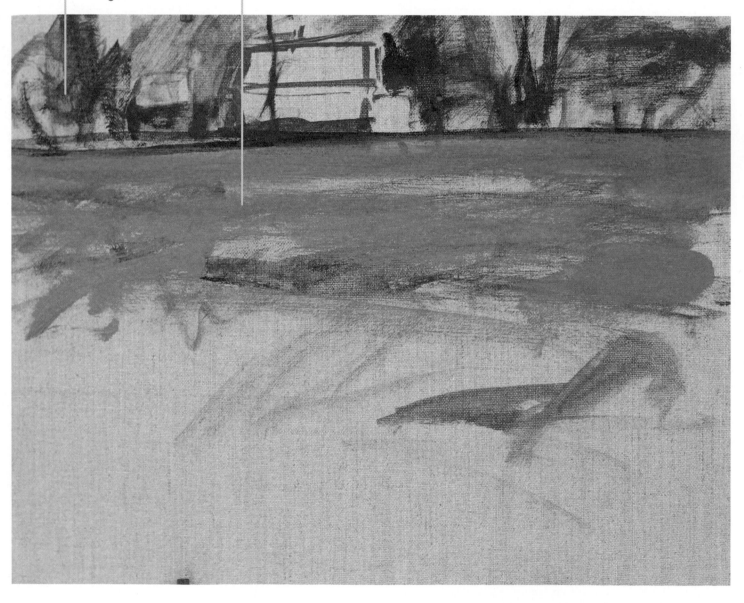

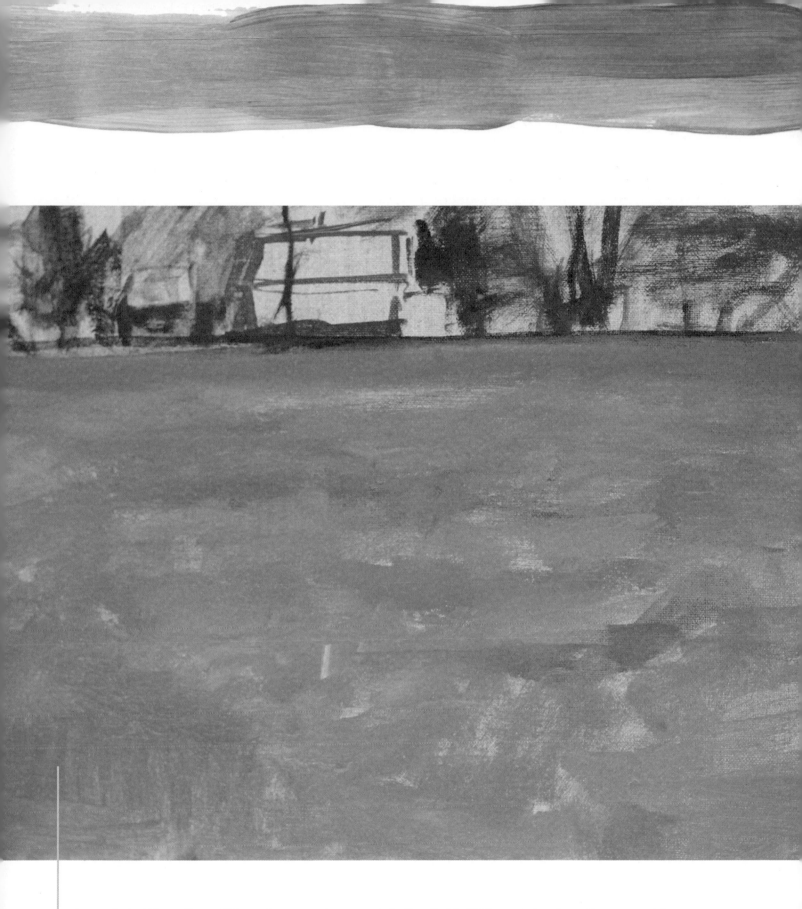

Loosely knit together different greens to complete the field. Different shades of green add visual interest.

ADDING VISUAL INTEREST

Use horizontal strokes for layers of grass and the flowers in the distance.

Roughly brush on the rooftops and some of the tones for the trees.

Some of the violet undertones remain visible.

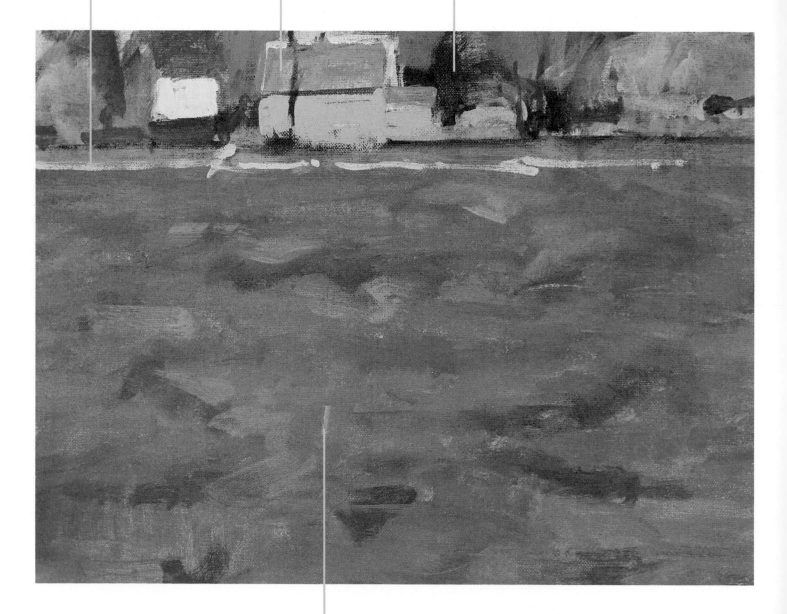

An errant color here and there is OK! Have fun with this painting, and don't worry too much about the details.

tip

USE A PALETTE KNIFE FOR RAPID APPLICATION AND BUILDING TEXTURES.

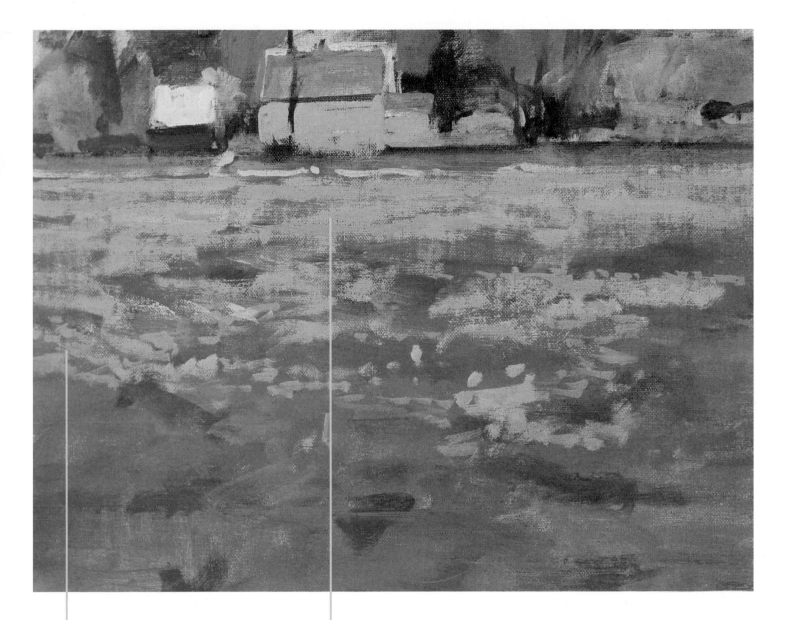

Different tints of yellow create more texture and visual interest.

Color-match the masses of yellow dandelions, and scumble on the flowers.

Paint the dark structures in the distance.

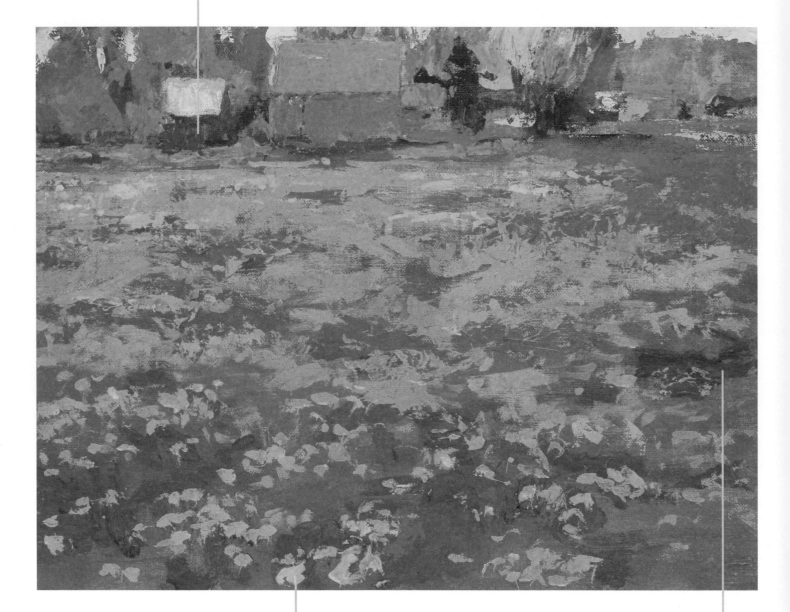

More palette knife work builds background masses as well as individual flowers in the foreground.

Brush on contrasting dark undertones in the green field.

A few details complete the painting.

Darks in the distant vertical planes and foreground add depth and texture.

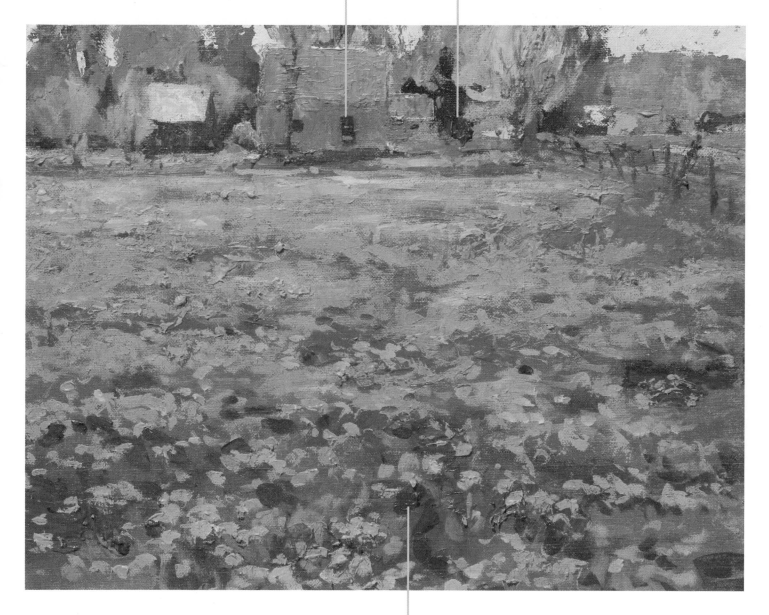

The impasto technique, or thickly applied brushstrokes, adds texture and dimension as well.

PAINTING NATURE

I started this painting on location (*en plein air*) and finished it in the studio. This is sometimes required when the weather suddenly changes and one must run for cover!

First, prime the canvas, and then block it in with very light-value, arbitrary colors for sunlit areas. An object's undertones can look similar or different from the final surface of a subject. The idea is to quickly establish the composition without worrying about details.

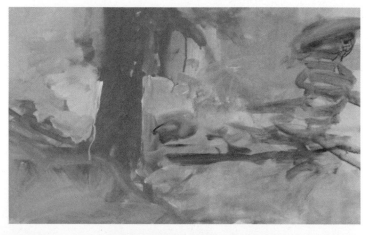

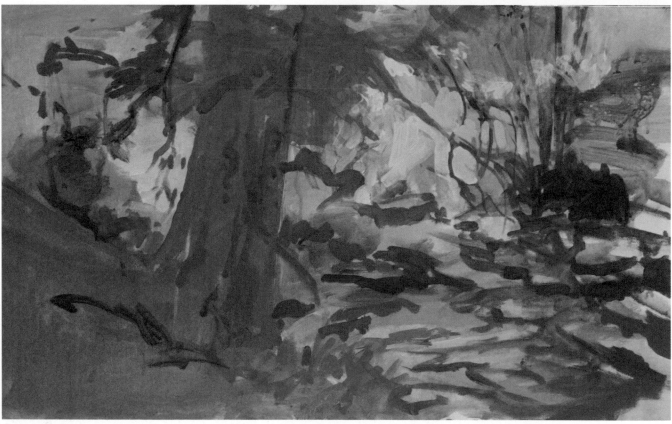

Layer initial values and colors as you familiarize yourself with the scene.

REGULARLY SPRAY WATER ON THE PAINTS ON YOUR PALETTE. THIS KEEPS PAINTS WET AND WORKABLE.

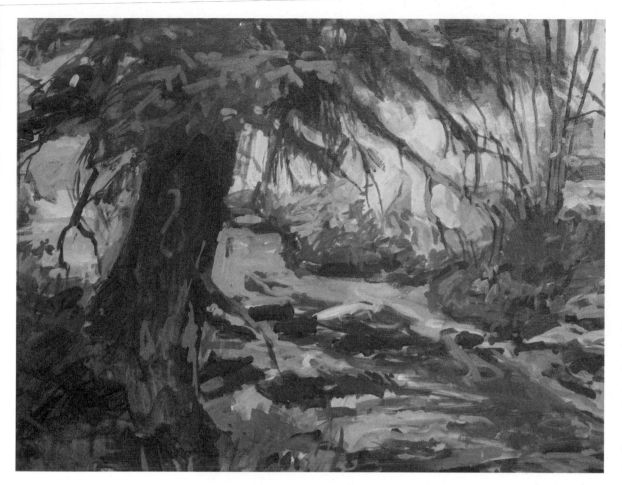

Start bringing in the dark values of the tree trunks and branches. These darks give your painting structure and contrast.

The stream, which flows toward the lower-right corner of the painting, needs a visual break to slow the eye from leaving the design. Add rocks in the stream and on its banks.

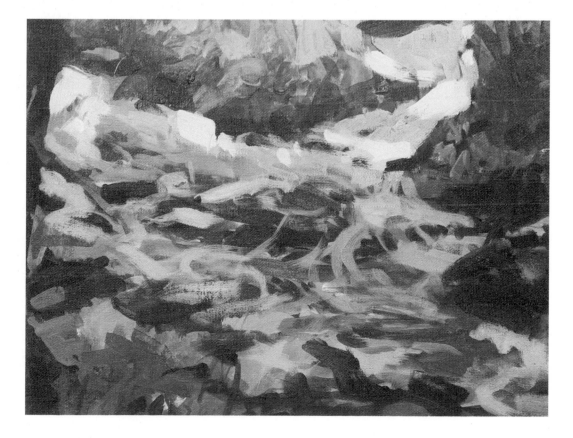

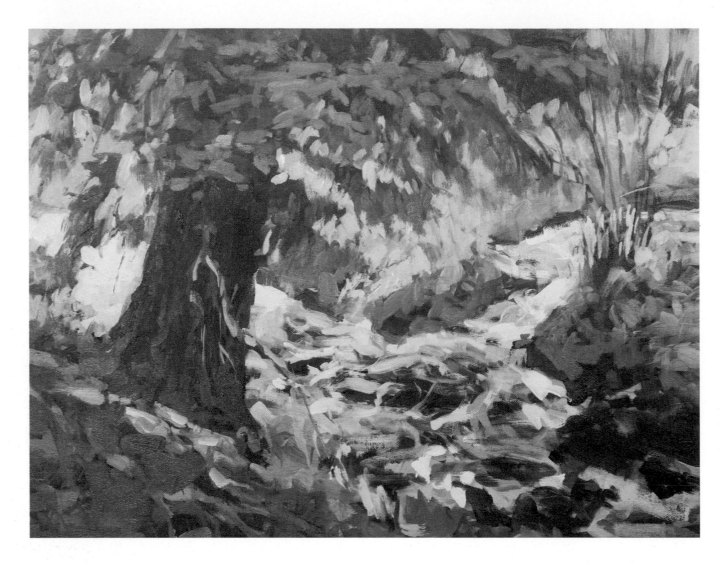

Build layers of rocks and debris that support the tree and define the shape of the stream's banks. Then add lighter values to the tree branches to give them a more three-dimensional form. These values also show the cool blue reflection of the sky, which you might see on the pine needles, leaves, and other vegetation.

ONCE THE PAINTING LOOKS WELL DESIGNED, IT'S TIME TO STRENGTHEN AND EMPHASIZE THE MOST IMPORTANT LIGHT AND DARK VALUES. SOMETIMES THE LAST 5 PERCENT OF THE PAINTING CAN MAKE 100 PERCENT DIFFERENCE. ADDING THE MOST ESSENTIAL DETAILS WITHOUT OVERDOING THEM IS KEY.

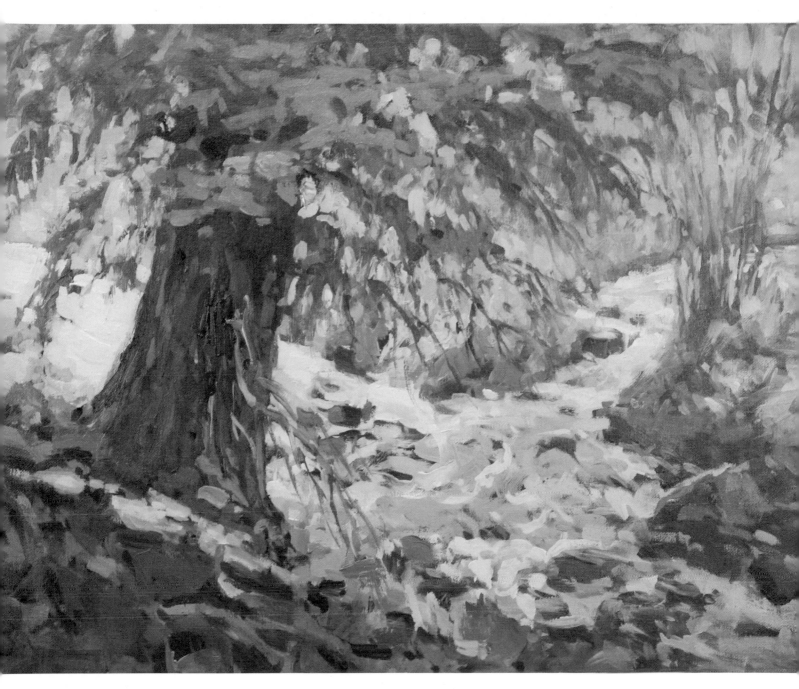

Here's what your final painting might look like. You may be tempted to add too many details, but being selective makes a huge difference toward telling a story and making a point without belaboring it.

PAINTING QUICKLY

With plein air painting, the goal is to work rapidly and efficiently. Try to perceive what's "under" all of that pesky surface detail.

Practice capturing the scene with a few quick charcoal sketches, or use a brush and diluted paint to sketch.

Paint rapidly with a larger brush to block in the main elements in the scene.

tips ● ● ●

RELAX, AND ENJOY THE COLORS! FOR THIS PAINTING, USE COLORS LIKE WHITE, YELLOW OCHRE, CADMIUM RED, ULTRAMARINE VIOLET, ULTRAMARINE BLUE, AND VIRIDIAN.

PRACTICE PAINTING AS OFTEN AS YOU CAN! THIS WILL SIMULTANEOUSLY TRAIN YOUR ARTISTIC EYE, HAND, AND INSTINCTS.

Block in the trees using a uniform tone of green mixed with a little orange or red. Keep them dark and fairly flat.

BLOCKING IN ALLOWS YOU TO ADJUST A PAINTING AS YOU GO. INSTEAD OF PLANNING A PAINTING IN DETAIL FROM THE BEGINNING, GRADUALLY REFINE COLORS AND SHAPES, ADD DETAILS, AND FINALIZE TONES.

Block in the sunny-looking sky with light blue colors.

MUCH OF WHAT YOU BLOCK IN WILL BE PAINTED OVER, SO YOU DON'T NEED TO BE TOO PRECISE.

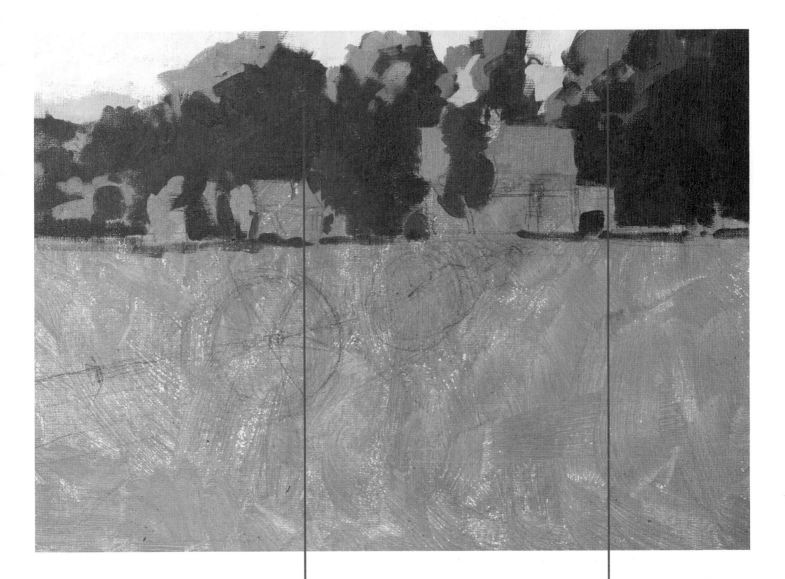

As you block in more of the tree shapes with lighter greens, the trees should start to take form.

Simplify and paint flat puzzle pieces of color for the main shapes in each subject.

SCUMBLING

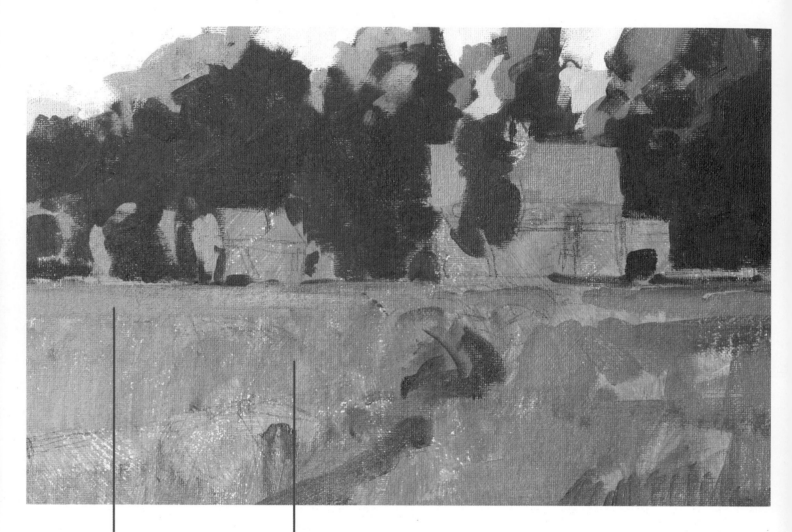

Drag a brush horizontally to paint the distant green field.

Masses of light and dark green color are scumbled in.

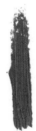

SCUMBLING ADDS A LAYER OF BROKEN OR SPECKLED COLOR OVER DRY PAINT, ALLOWING SOME OF THE UNDERTONE TO SHOW THROUGH. THIS PROVIDES THE AREA WITH DEPTH.

A small flat
brush catches
the dark
window.

Capture
the violet
undertones
of the larger
farmhouse.

COMPLEMENTARY COLORS,
SUCH AS BLUE-VIOLET
AND YELLOW-GREEN,
CREATE LIVELY, EXCITING
CONTRASTS. A COLOR
WHEEL CAN HELP YOU
CHOOSE A COLOR SCHEME
FOR YOUR PAINTING.

Add darker values for the ditch
in the center of the painting and
some areas of grass.

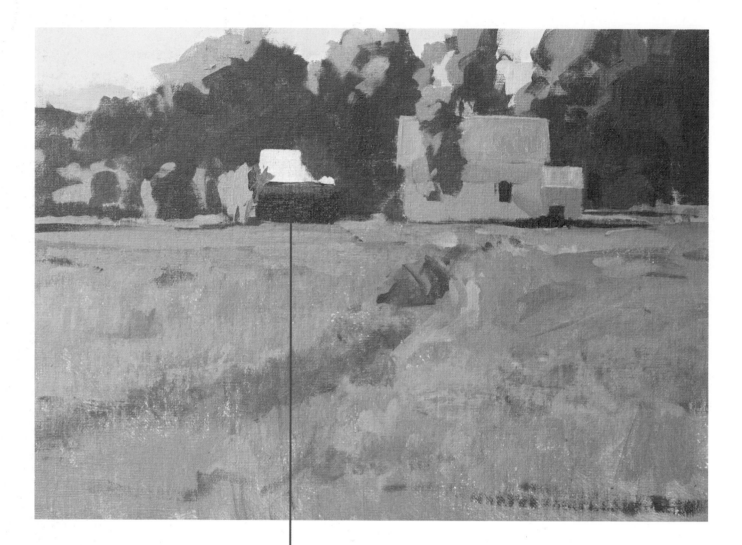

The shed needs light and dark values for its white roof and dark red exterior.

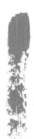 **MANY ARTISTS LOVE THAT ACRYLIC PAINT DRIES QUICKLY, AS IT ENCOURAGES LOOSE, LIVELY, SPONTANEOUS STROKES. YOU CAN USE A RETARDER OR MEDIUM IF YOU WISH TO SLOW DRYING TIME.**

Shadows add realism.

Add additional values and color changes as well as layers of paint to build texture.

Soften and shape edges when necessary.

Details in the foreground make the painting come alive.

tip

ACRYLIC PAINT DARKENS AS IT DRIES. BEFORE PAINTING, IT CAN BE HELPFUL TO CREATE COLOR CHARTS, WHICH ALLOW YOU TO SEE EACH PAINT'S TRUE COLOR WHEN IT DRIES.

BUILDING TEXTURE

This garden's tangled complexity is captured through the simple process of building layers of texture. You can almost sense the energetic process of spattering, tapping, and stroking layers of paint on the canvas.

Notice the loose and broken brushstrokes. Splash and dab paint using the tip and side of your brush. Try out other tools as well.

If you are painting in the garden, keep your eyes on the subject as much as possible without focusing on your painting surface. It will look chaotic at first!

tip

THIS PAINTING USES COLORS LIKE YELLOW-GREEN, WARM REDS AND ORANGES, WHITES, AND PINKS TO CONVEY A VERDANT GARDEN SCENE.

Keep the light and dark values in mind as you quickly glance at your subject.

Throw some paint on the canvas, alternating brushing and spattering methods.

SOMETIMES YOU HAVE TO JUST LET YOURSELF GO. FEEL THE SENSATION OF FLINGING, DABBING, AND SCRUBBING LAYERS AND COLORS, AND EMBRACE THE FREEDOM THAT COMES FROM INTUITIVELY PAINTING WITH COLOR. GIVE YOURSELF PERMISSION TO INVENT UNIQUE MARKS AND STROKES!

Lay down wet paint, and use a rubber shaping tool (see page 13) to cut through the wet surface and give it a more structured, linear quality.

Dab on some intense red colors in grouped patterns.

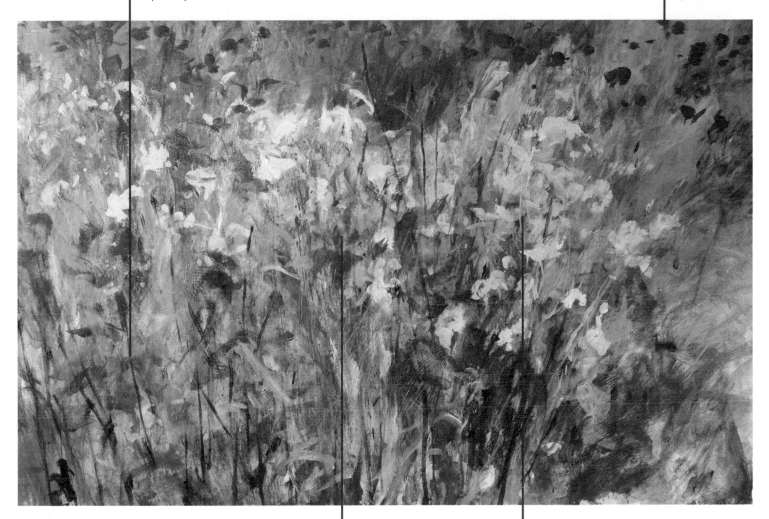

Lay down several layers of paint.

Build patterns of light yellow and green next to the darker, warmer reds and oranges.

tip ●●●

STROKING A THICK LAYER OF PAINT OVER A THIN WASH LETS THE UNDERPAINTING PEEK THROUGH TO PRODUCE VARIETIES OF COLORS AND TEXTURES.

Keep building layers and textures while adding light and dark areas.

Now that the underpainting is established, add the more defined and prominent flower shapes in white, pink, and red tones.

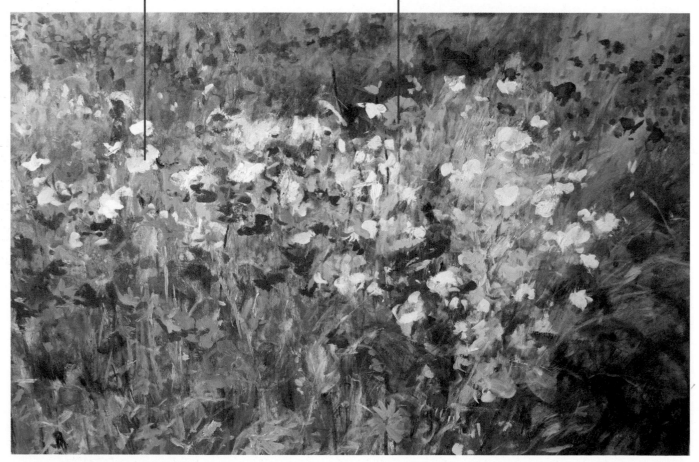

Use a small,
stiff brush to
quickly define
the slender
grasses.

Notice that some flowers are
still free-floating, while others
are connected to stems.

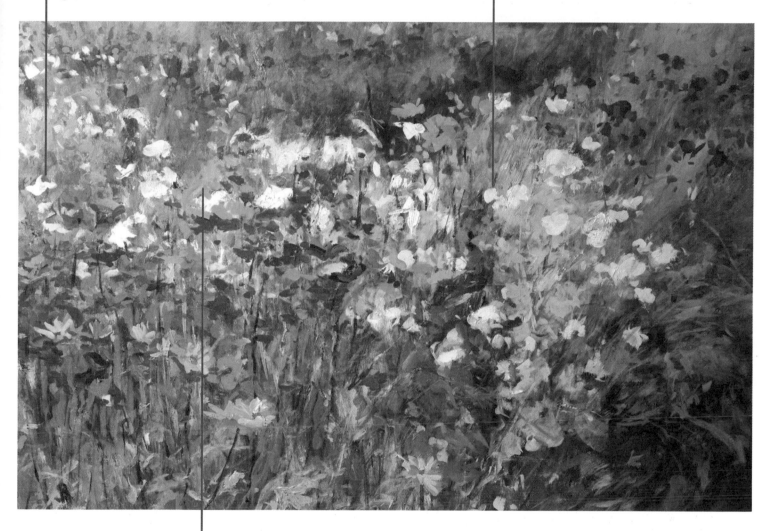

Build more and more layers, and
start to connect the stems with a
few prominent blossoms.

FLORALS OFFER A GREAT INTRODUCTORY SUBJECT FOR ACRYLIC PAINTING. BECAUSE THEY'RE STATIONARY, YOU CAN REALLY STUDY YOUR SUBJECTS' COMPOSITIONS, SHAPES, SHADOWS, TEXTURES, AND COLORS.

ADDING DETAILS

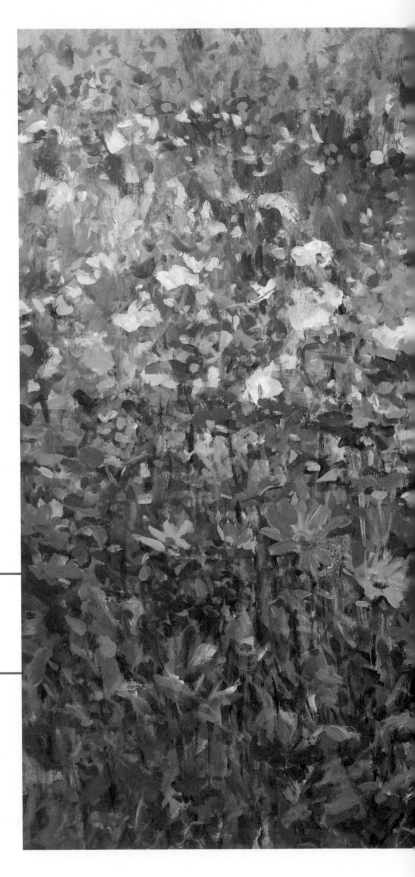

WHEN PAINTING OUTDOORS, CONSIDER THE ANGLE OF THE SUN. DURING MIDDAY HOURS, THE LIGHT LOOKS FLATTER AND THE SHADOWS ARE LESS VISIBLE. WHEN THE SUN IS STRAIGHT OVERHEAD, THE SHADOWS ARE LESS DRAMATIC. EARLY MORNING OR LATER AFTERNOON PAINTING SESSIONS OFFER DRAMATIC LIGHT.

A rigger brush or the tip of a stiff bristle brush pressed on its edge will slide across the canvas to create fine lines.

The finished artwork shows its spontaneous, free-flowing painting process.

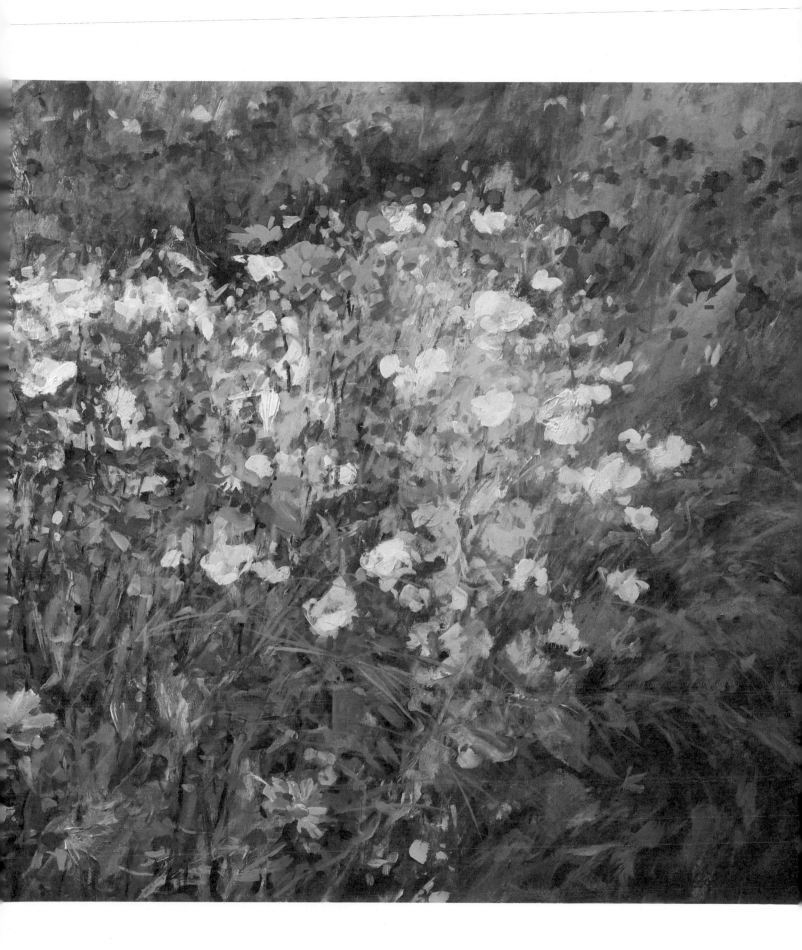

PAINTING WITHOUT DETAILS

Here's a little secret about painting. Turn this book upside down, and look at the nine paintings on these two pages one by one. Notice how the subject, which is fairly complicated, comes together almost like a jigsaw puzzle. The details aren't added until later in the process.

Of course, it's not really practical to do this on location unless you're comfortable standing on your head for an hour or two. In the studio, using a reference photo can help. If you're painting outside, keep a mirror with your plein air gear, and frequently turn your head to the side while looking back at your scene in the mirror. This shift in perspective helps you see mistakes.

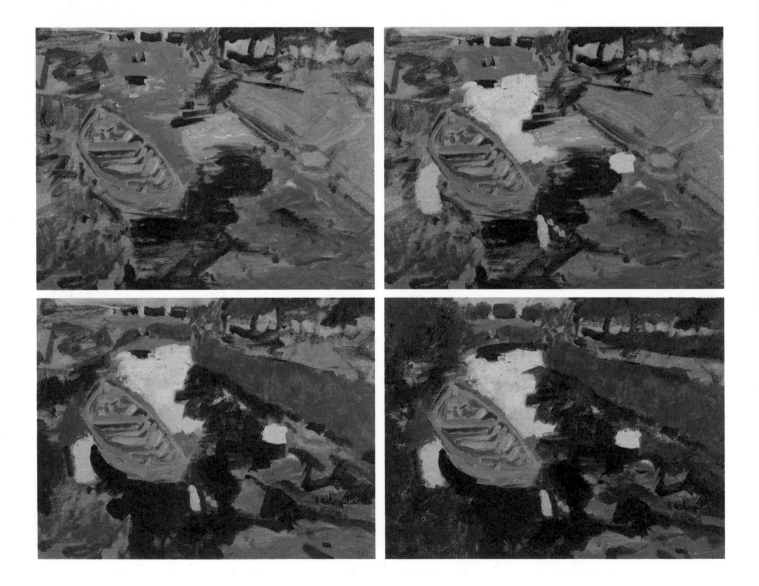

These two techniques are helpful because they allow you to easily see the shapes of the subject. Our brains are loaded with images that we've memorized and associated with certain things. That's why most beginning drawing students draw cartoonlike images when first starting out. In nature, though, the shapes, masses, and light and dark values are much more varied and complicated than, say, a green lollipop used to represent a tree.

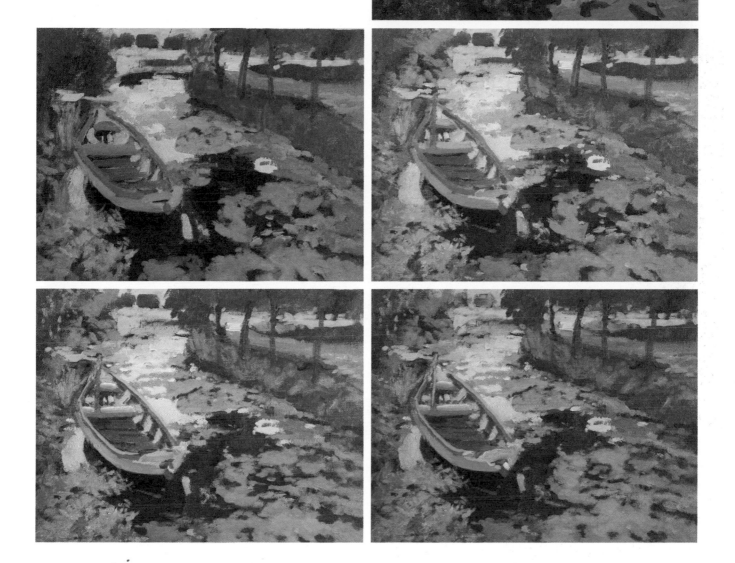

tip

A VIEWFINDER CAN HELP SIMPLIFY THE SUBJECT IN FRONT OF YOU SO THAT YOU FOCUS ON MANAGEABLE, SIMPLIFIED SHAPES, PATTERNS, AND COLORS.

HARMONIZING

Try painting the following piece upside down. Ignore the details and the results, and keep yourself guessing. Then take a look at the result, and notice how accurately you've seen the subject.

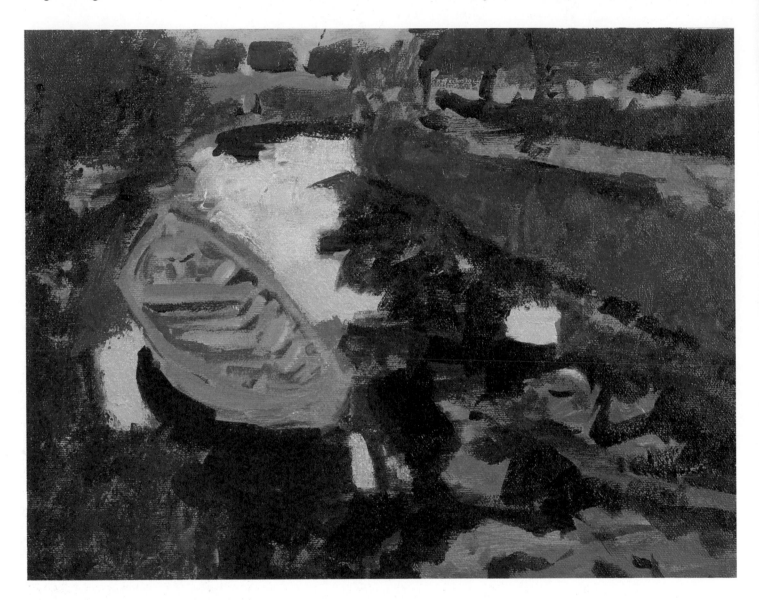

On a warm-toned canvas, loosely sketch the main shapes while laying in the darkest and lightest shapes. Add patches of blue to indicate the reflection of the sky on the water. Use green to represent the grasses and foliage along the edges of the pond. The green spots also create a sense of harmony. Then add some patches of darker colors, such as violet, sienna, and blue, for the shadows.

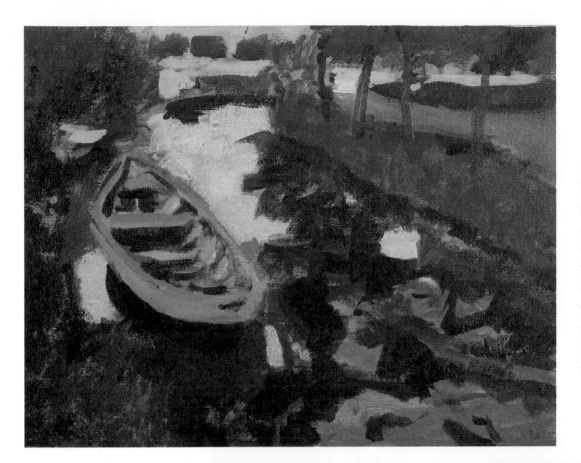

Lighter greens indicate distant grasses and the side of the boat. Add a color like mauve for the sidewalk and as an undertone for more patches of foliage. A patch of light pink indicates the sky.

Patches on the surface of the pond represent floating moss and vegetation.

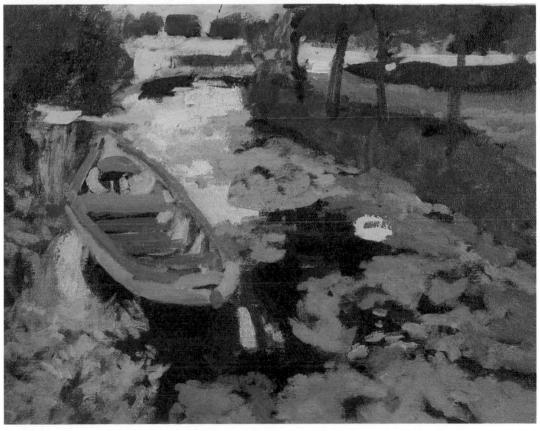

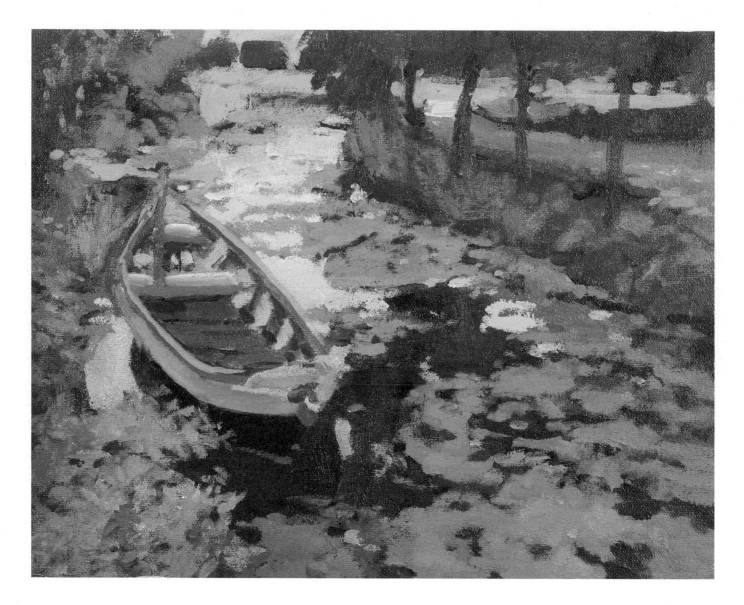

Build up the boat using patches of brown and red-orange. Add patches of darker blues in the water. Add patches of peach to the sidewalk and small touches of lighter colors to indicate the flowers on the pond.

Now add connecting patches of color to unify certain areas, such as the dark water and vegetation. This helps support the boat, which should look like it is in the water and not as though it's floating above the water.

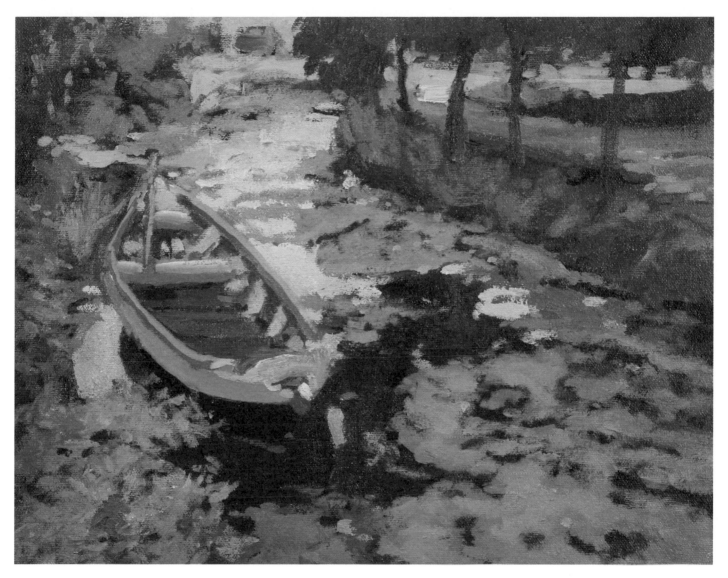

 THIS ENTIRE PAINTING CONSISTS OF PIECES OF COLOR IN VARIOUS SHAPES AND SIZES. YOU DON'T NEED TO DEFINE YOUR DETAILS PERFECTLY; YOU CAN BE MORE FREE WITH YOUR BRUSH.

ADDING ACTIVITY

This painting of my young daughter and her friend at the beach reminds me of some happy childhood memories of my own. The children are painted loosely and without hard edges, so the viewer's focus naturally falls on what the subjects are doing.

tip

THIS PAINTING USES WARM AND COOL PRIMARY COLORS.

Keep the sky light and cool.

Suggest distant cliffs and water with light values similar to those in the sky.

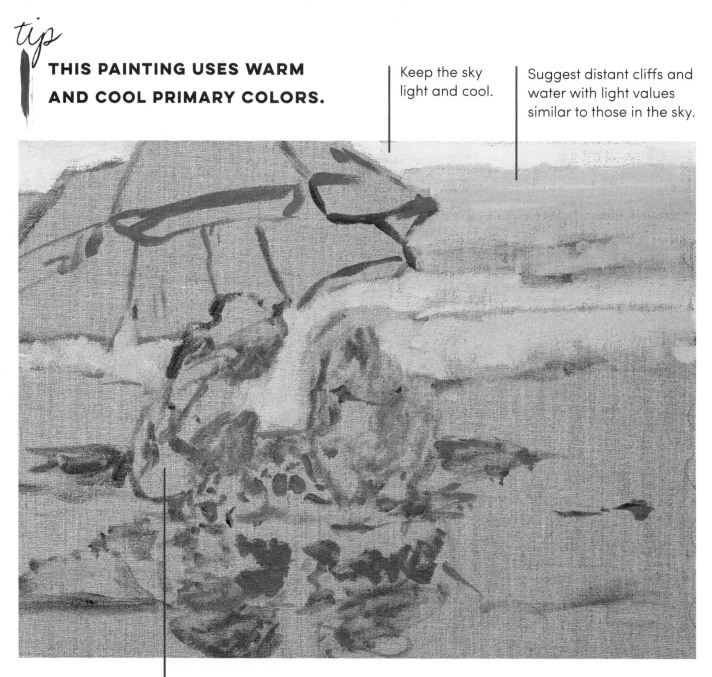

Minimal lines indicate the positions of the various elements.

Sketch the umbrella now, and fill in the colors later.

The children's shadowed flesh tones are among the darkest in the painting. A mixture of ultramarine blue, orange, and white works well here.

Block in light blue around the figures to indicate water. This is the largest mass in the painting and should be darker than the sky.

EMPHASIZING FIGURES

This painting consists of patches of paint.

This figure's hair is shadowed, so light blue-gray forms a good base. Keep the value similar to her skin tone.

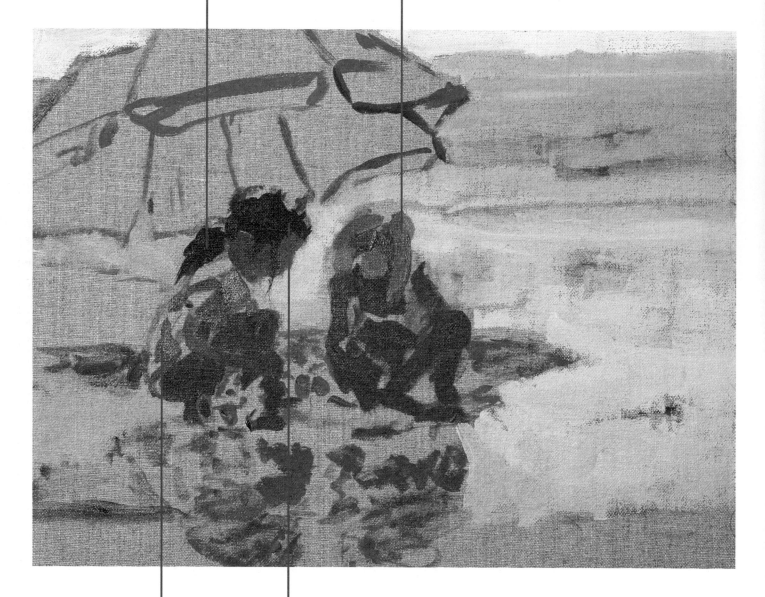

The values in the shirt should be close to the figure's skin tones.

Use care when blocking in this figure's hair. Highlights will come later.

Add the first indications of the lightest parts in the painting.

The sky shouldn't compete with the strong lighting on the girls' hair and clothing.

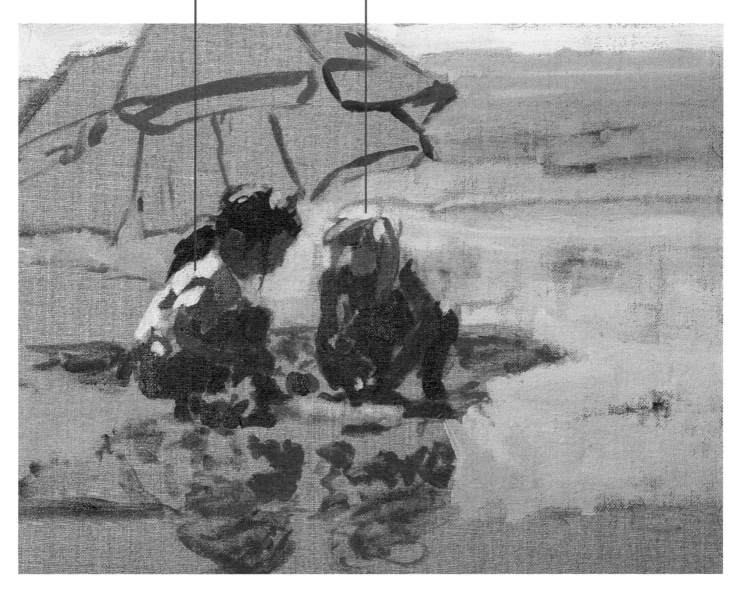

tip

BESIDES PRIMARY COLORS, THIS PAINTING USES VIRIDIAN, TURQUOISE BLUE, AND TITANIUM WHITE.

BLOCKING IN

Block in the first of the primary colors on the umbrella.

Bright colors add interest and contrast while leading the viewers' eyes back down to the figures.

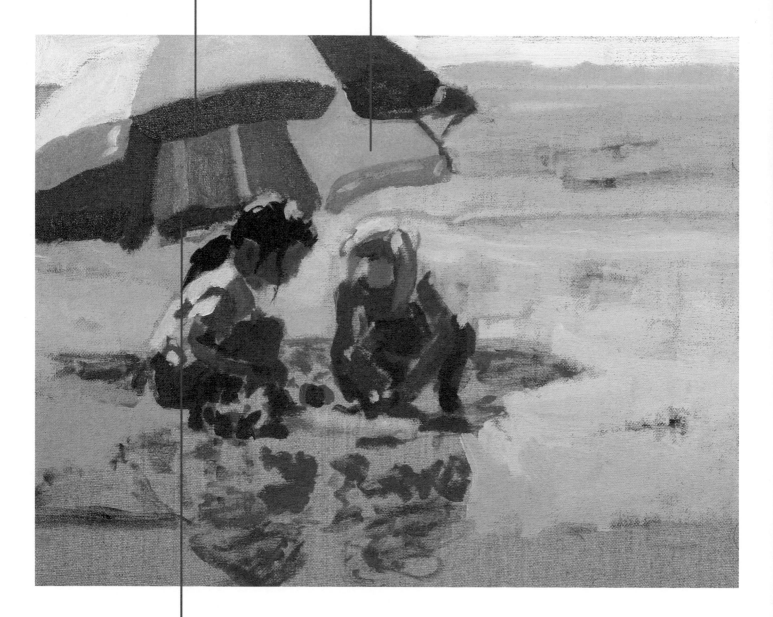

Dark blue supports the emphasis on the dark-haired child's head and maintains that figure as the focal point of the painting.

Colorful, subdued reflections balance and surround the figures.

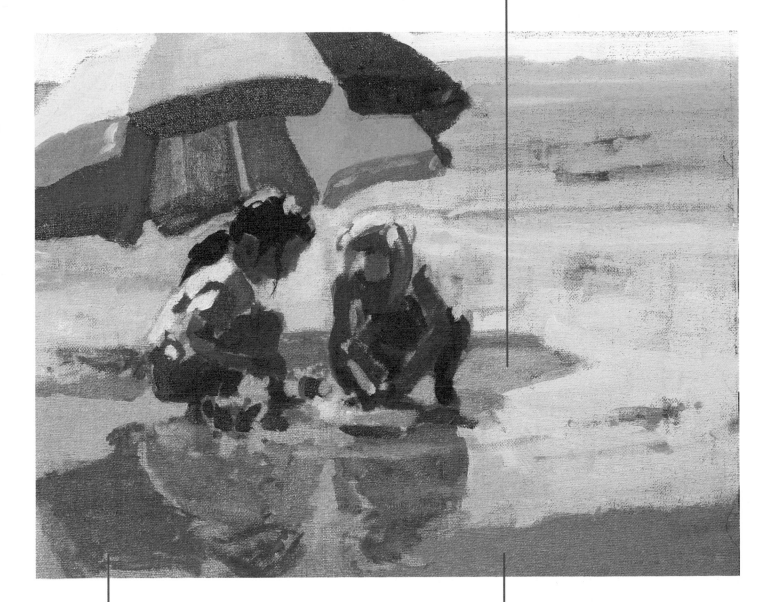

Reflections are visible in the bottom portion of the painting and less intense than the umbrella above.

Paint neutral tones with a mixture of blue, orange, and green in the sand. Add more orange and red for the darker flesh tones.

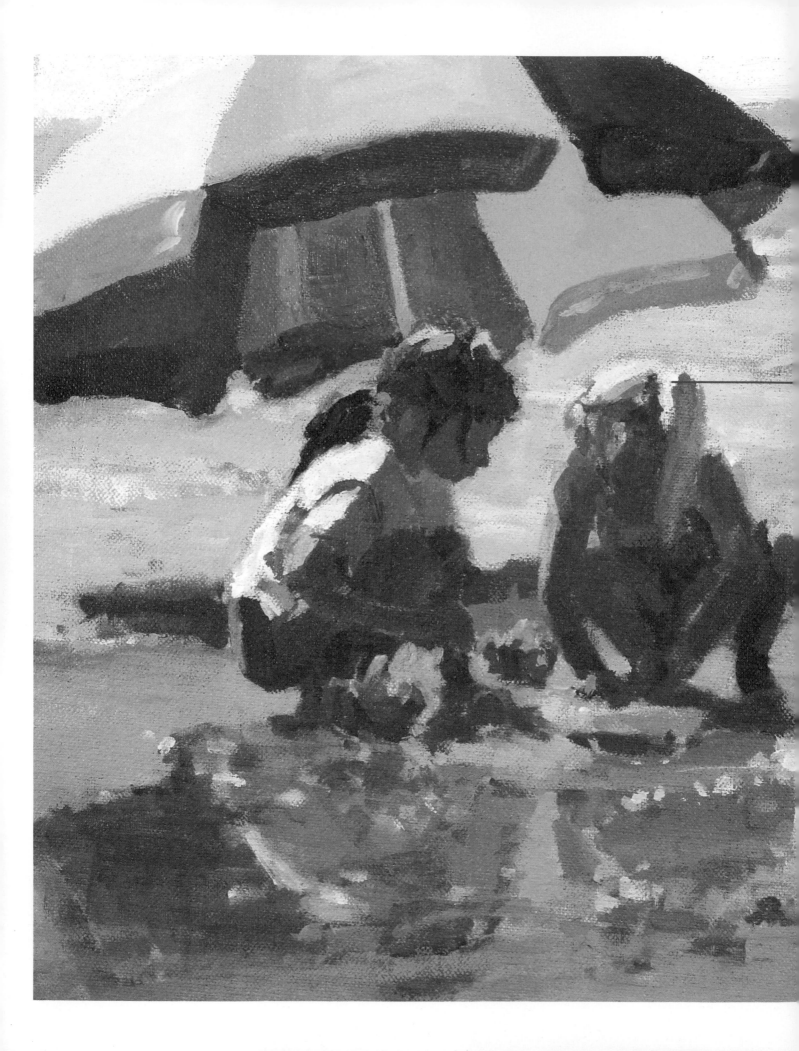

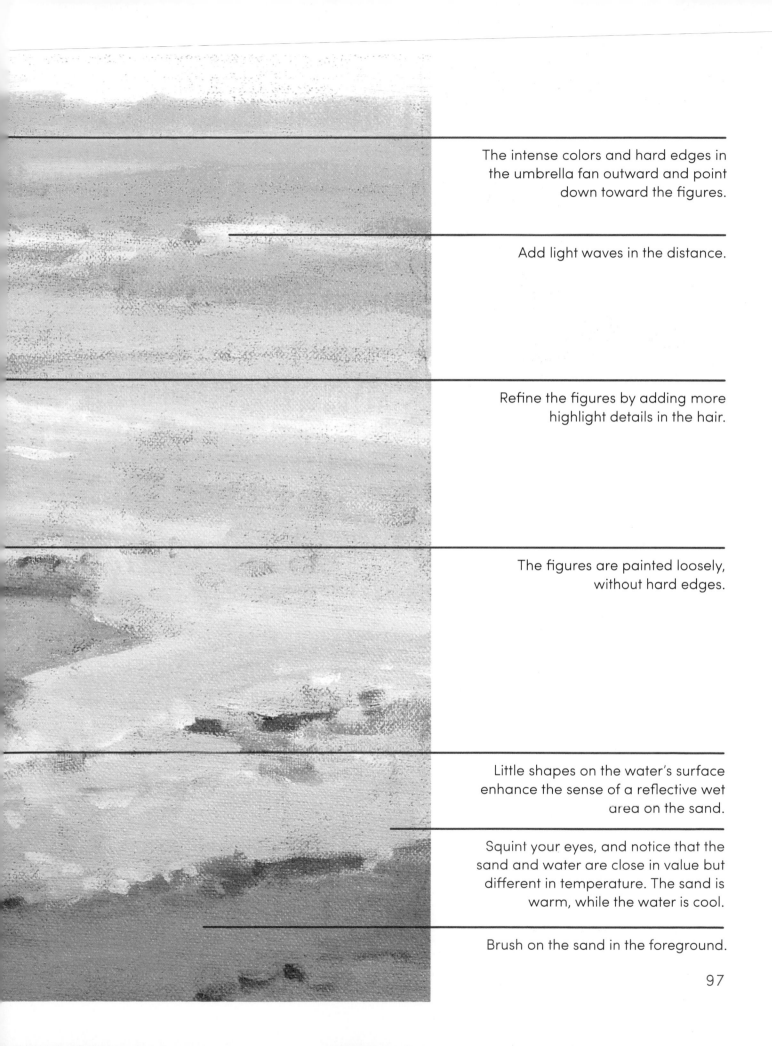

The intense colors and hard edges in the umbrella fan outward and point down toward the figures.

Add light waves in the distance.

Refine the figures by adding more highlight details in the hair.

The figures are painted loosely, without hard edges.

Little shapes on the water's surface enhance the sense of a reflective wet area on the sand.

Squint your eyes, and notice that the sand and water are close in value but different in temperature. The sand is warm, while the water is cool.

Brush on the sand in the foreground.

STUDYING VALUES

This is a small (5" x 7") acrylic color study. Acrylic paints work wonderfully well for small, quick studies like this one because the paints dry quickly. Color studies provide you with a "feel" for your subject and the painting's composition. Details are ignored—just basic colors and values are represented.

Color Challenge!

Try doing a few of these color studies like the one above every day for a month instead of finishing an entire painting. Set your timer for 20 minutes, and don't worry about getting your color study perfect. You will end up with a series of delightful, fresh renderings of many different subjects that can be stored away as your skills develop or displayed together as your collection grows.

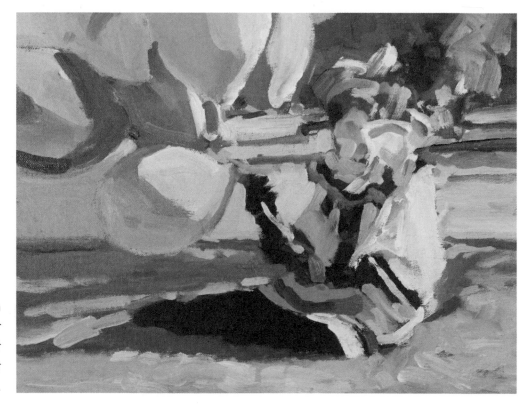

Establish the main masses in your painting without worrying about details.

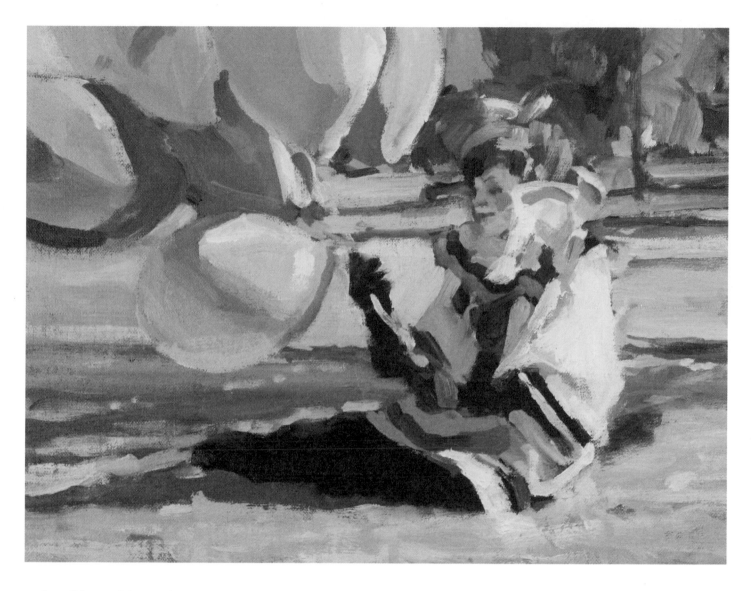

Small bits of the pink underpainting show through, providing a unifying effect to the painting. Soften some edges, and leave others hard in preparation for adding color. Add general facial features with just a few brushstrokes.

tip

VALUE STUDIES CAN ALSO BECOME BEAUTIFUL, ACHROMATIC PAINTINGS GIVEN A LITTLE BIT OF REFINEMENT.

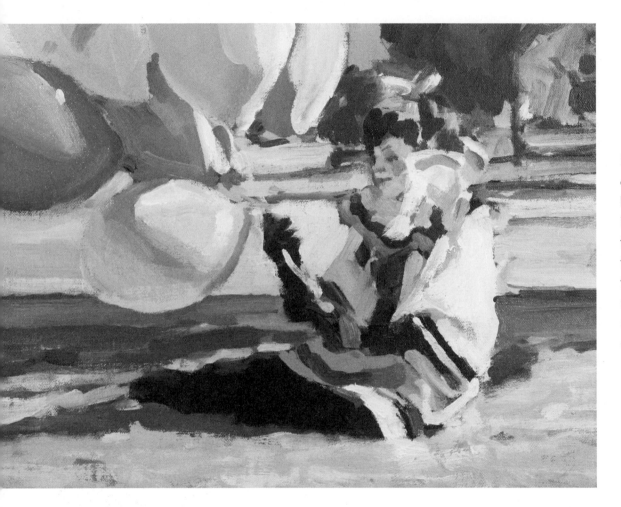

Painting lights and darks into the blue balloon gives it the illusion of three-dimensional form. The tree in the background remains very neutral in comparison.

tip

WHEN CREATING THREE-DIMENSIONALITY IN A PAINTING, THINK LIKE A STILL-LIFE ARTIST. DEMONSTRATE HEIGHT, WIDTH, AND DEPTH IN OBJECTS THROUGH THE USE OF LIGHT AND SHADOW.

Paint all of the balloons using the light and dark values of various colors. The shadowed objects will look less three-dimensional than the ones in light and shadow.

The ground colors become cooler as the ground recedes into the distance.

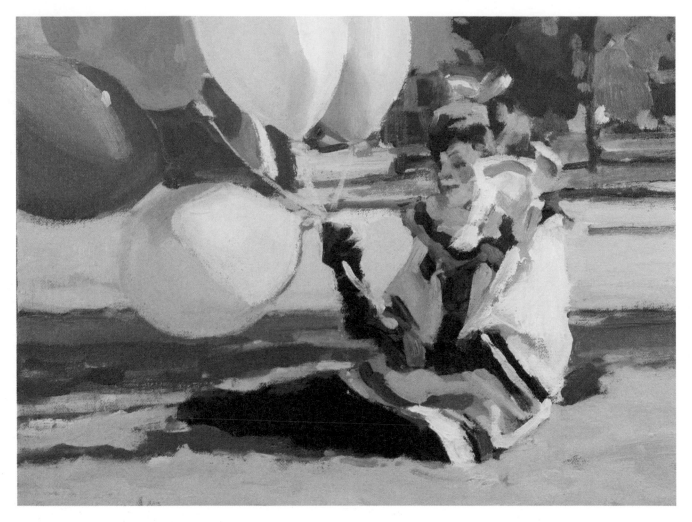

The ground stays neutral. Block it in with a light mixture of white, ochre, and blue.

Add key details to help the figure's face materialize, such as color to her face and hair.

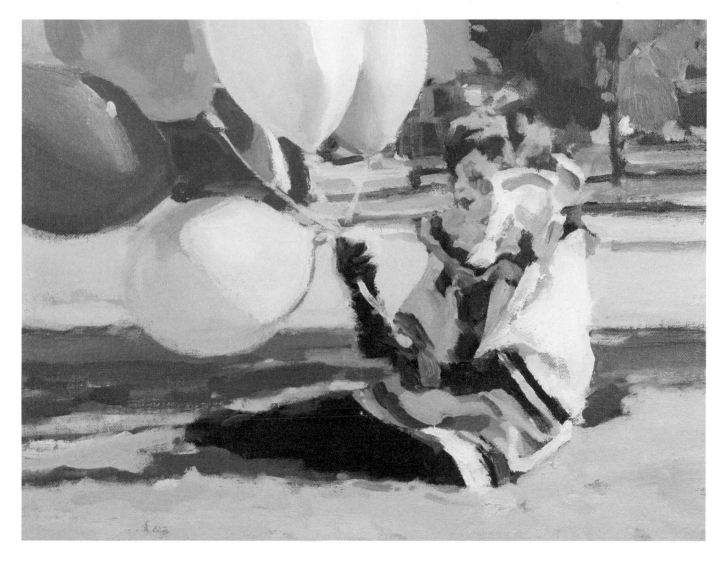

The final painting shows a strong play on light as well as more subtle shifts in color temperatures and values. Notice how effective the black, white, and gray costume is as a counterpoint to the colorful balloons.

SQUINT YOUR EYES, AND TRY TO RECOGNIZE THE BASIC LIGHT AND DARK PATTERNS THAT YOU CREATED IN THE ORIGINAL SKETCH.

CREATING WARMTH

This mountain landscape features cool tones at first, and then warmer tones are added. By the end, this nature scene will look quite warm despite its elevation.

First block in the main shapes in the painting, starting with the darkest masses—the trees.

Add masses of middle values in the foreground, working around the dark shapes you already created. Focus on simple lines that move downward and form the general shape of a mountain.

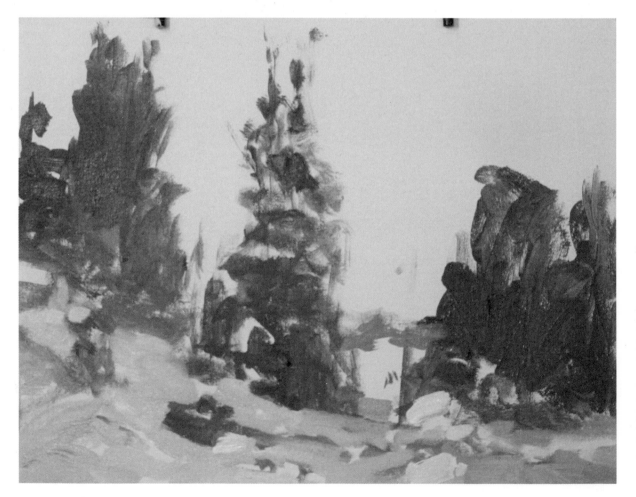

Establish more values, shapes, and patterns. Use cool tones, and add to some of the tree forms as well.

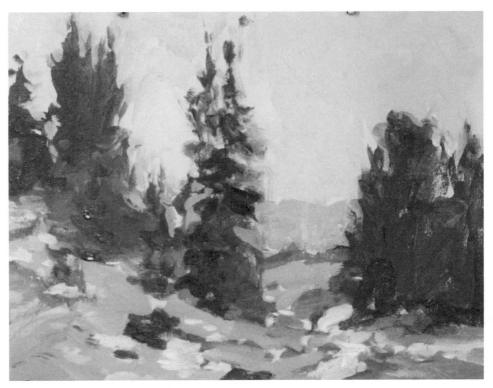

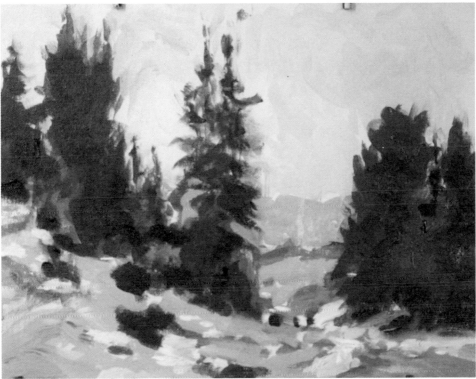

Loosely block in colored masses over the tree shapes to form an important base.

tip

TO PAINT THE TREES, COLORS LIKE SAP GREEN OR HOOKER'S GREEN CAN BE MIXED WITH SMALL AMOUNTS OF ORANGE, BLUE, OR RED TO CREATE VARIATIONS IN TEMPERATURE.

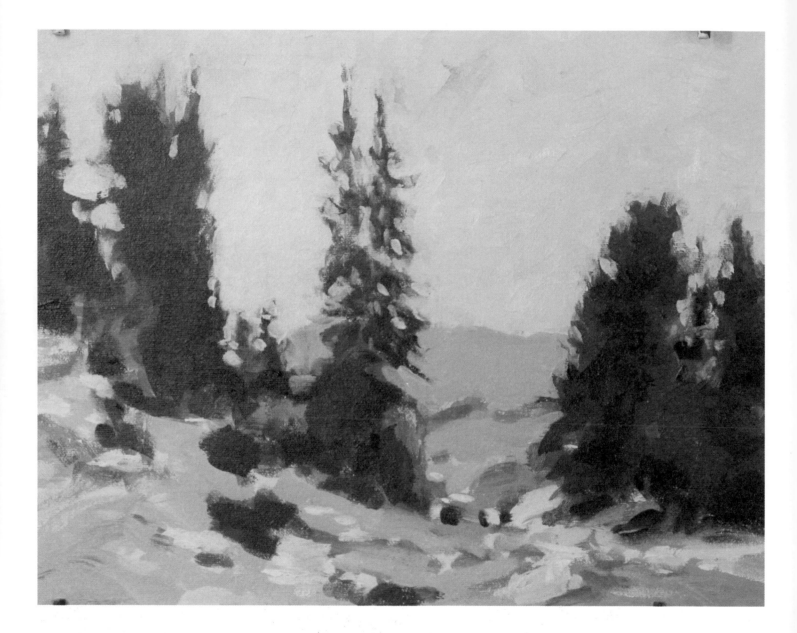

The sky forms the lightest, largest mass in the painting. White, cobalt blue, and a little bit of yellow will warm up the sky mixture. The sky should look slightly cooler at the top of the painting than near the mountain. Add a little bit of this color mixture to the trees too. Don't forget the mountain in the distance, which can be painted with a mixture of blue and a tiny bit of alizarin crimson.

Use warm colors to indicate the mass of trees in the middle distance (in the center of the painting). To paint the grass, use single brushstrokes in mixtures of colors using orange, raw umber, and cadmium red. Greens and blues can be added to the center of the painting to indicate the hills in front of the distant mountains.

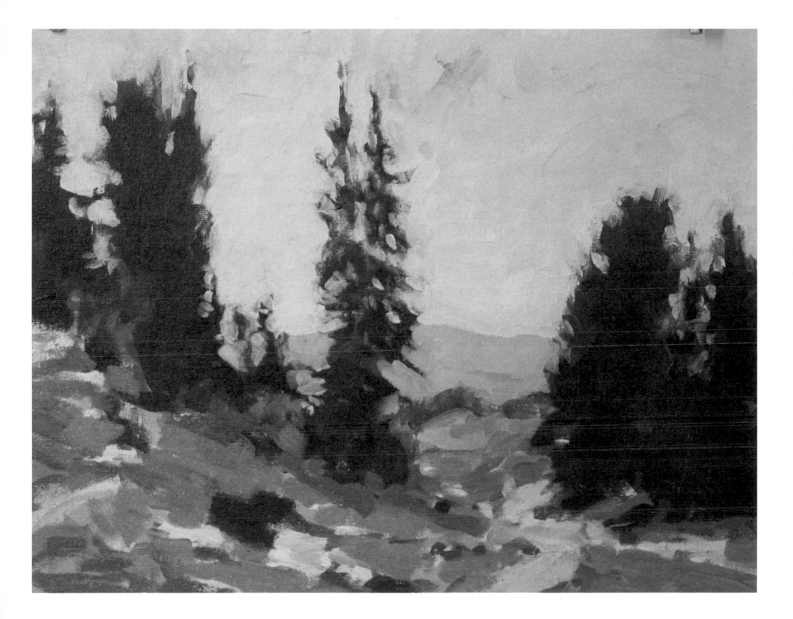

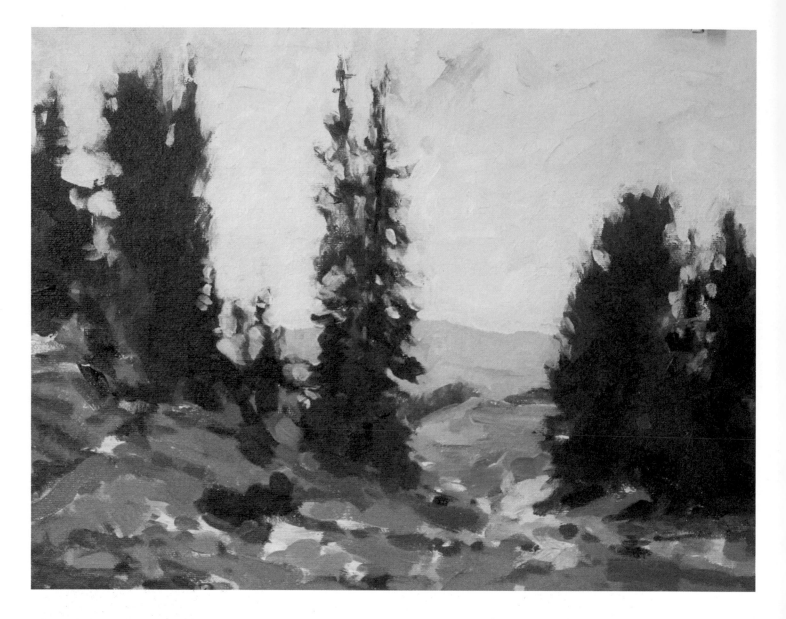

Give the rocks in the foreground a shadowed side and a lighter side (facing the light source) to create form. The lighter side should feature warmer tones, and the shadowed side cool tones. To ground the rocks, paint shadows under them.

Finally, work your way around the painting using both warm and cool tones. Make sure you maintain the correct value in the main mass of each area. When you're finished, the sky should look warmer, and the ground should feature a variety of impressionistic shapes and colors.

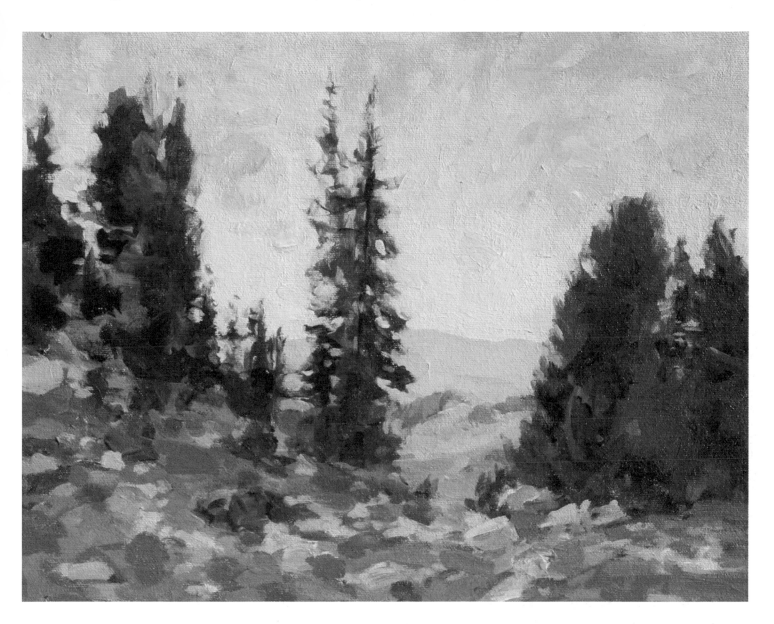

AERIAL PERSPECTIVE IS A TECHNIQUE THAT CREATES THE ILLUSION OF DEPTH. FAR-OFF OBJECTS, SUCH AS MOUNTAINS, ARE PAINTED WITH FEWER DETAILS AND USING PALER BLUE OR VIOLET TONES. THE CONTRAST BETWEEN THE OBJECT AND ITS BACKGROUND DECREASES AS THE DISTANCE FROM THE VIEWER INCREASES.

CHANGING TONALITY

Now let's descend from the mountains and paint a hotter, drier scene. This painting uses many of the same techniques as the previous one, but with different tones.

Sketch the values to establish the horizon line. Allow for an expansive sky, just like you might see in the desert. Use very diluted paint to create light, undefined cloud values in the sky.

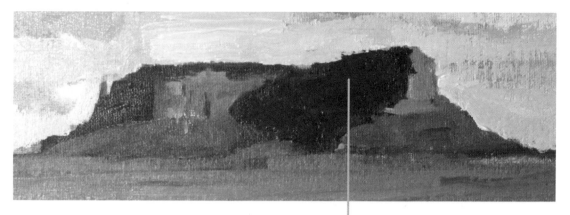

Brushing thick paint with horizontal strokes creates the rock formations using the darkest values in the scene.

Remember complementary colors, which we discussed on page 27? Here I've used violet and its complement, yellow.

Warm, earthy tones can be created with a mixture of ochre, sienna, and green to paint the foreground.

The sky is painted with an interesting mix of greens and yellows, and their complementary colors, red and violet, are mixed for the shadows on the clouds.

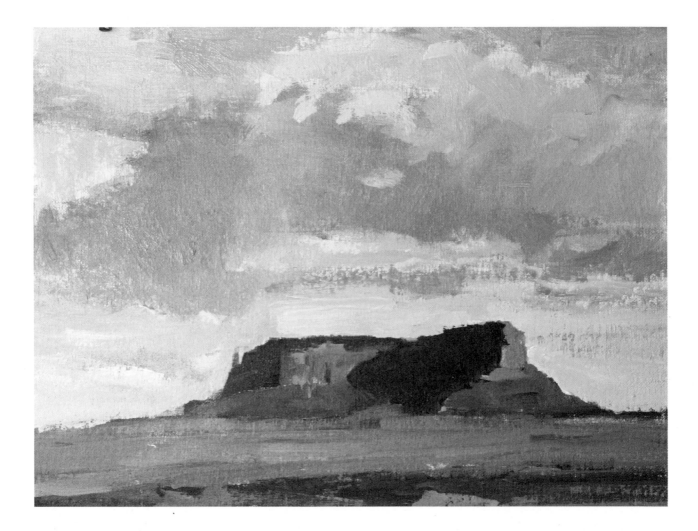

SQUINT YOUR EYES, AND NOTICE THAT THE SKY IS PAINTED WITH COLORS THAT ARE LIGHTER THAN ANY OF THE COLOR VALUES YOU SEE IN THE ROCK FORMATION OR THE GROUND BENEATH IT.

The light, fluffy clouds above contrast with the flat undersides of the clouds, which are painted with darker values.

CREATING HIGHLIGHTS

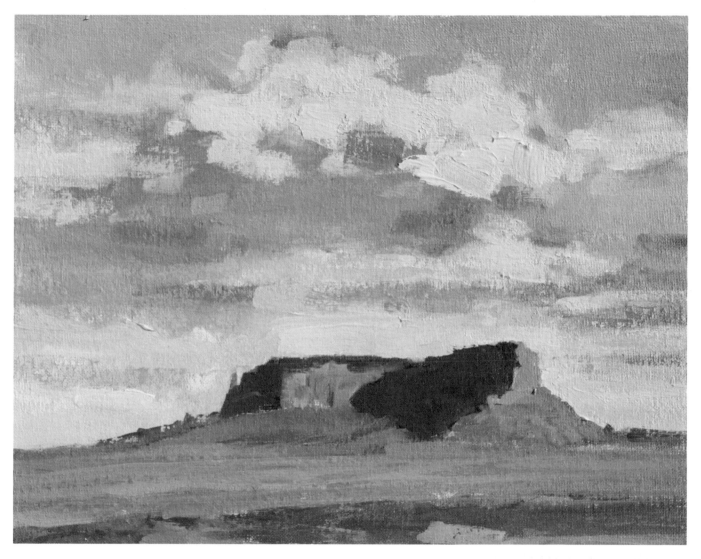

THICK BRUSHSTROKES GIVE THIS PAINTING A SENSE OF IMPASTO. IMPASTO IS A PAINTING TECHNIQUE THAT'S CHARACTERIZED BY THICKLY APPLIED, DIMENSIONAL BRUSHSTROKES. TO RECREATE THE IMPASTO TECHNIQUE, USE A PAINTBRUSH OR PALETTE KNIFE TO APPLY THICK, DIRECTIONAL STROKES, CREATING RIDGES OF PAINT. THIS TECHNIQUE CAN BE USED TO BUILD HIGHLIGHTS IN A PAINTING.

QUICKLY CAPTURING A SCENE

This old, unlived-in house presents the picture of contentment on a summer's day. The late sun casts lovely shadows across the thick, green lawn, and dandelions pop up here and there like mischievous little elves.

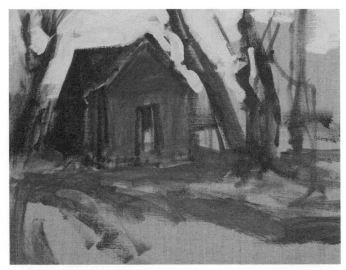

For the initial sketch, paint the main colors and values so loosely that the piece looks a bit like a young child created it. The goal is not to feature a lot of details; it's to quickly capture the main elements of the scene.

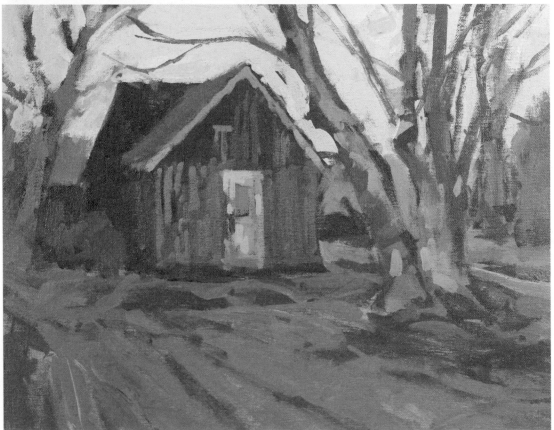

Block in the entire canvas.

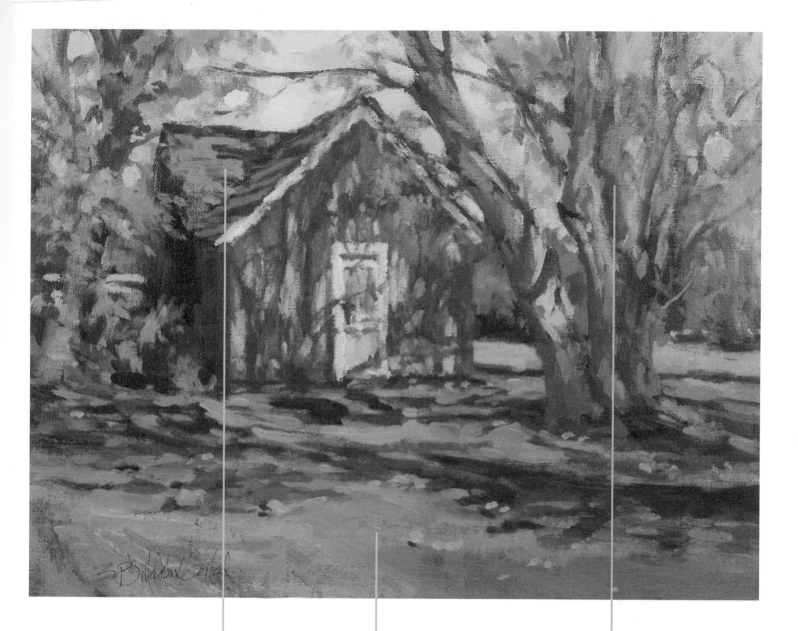

Areas like the tree and the house reflect the warm afternoon light created by mixing cadmium red and orange.

Paint the sunlight's strong patterns on the grass.

Work small patches of warm and cool variations into the entire painting.

SOMETIMES, A POP OF EXAGGERATED COLOR IS ALL THAT'S NEEDED TO ADD A SUNNY AFTERNOON GLOW TO A PEACEFUL SCENE LIKE THIS ONE.

LIGHT VALUES & CONTRAST

Cats make interesting subjects for paintings. Here you will notice the cat's graceful dark form silhouetted against the midtones of the surrounding environment, which contrasts with the gauzy white curtains. Your eye moves around the painting from the window's angular lines to the focal point of the cat's body and head.

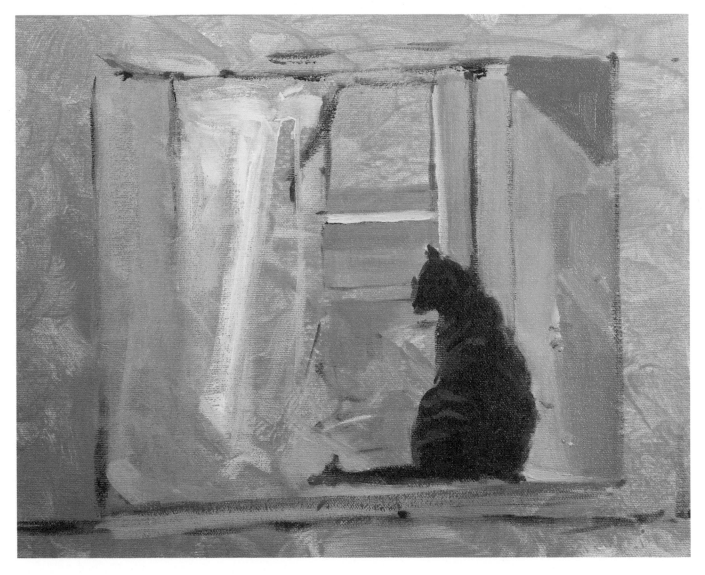

Do an initial drawing on a toned canvas. The white paint serves as a relative light value for all of the other values and colors to work against. Small touches of red accent the subject and indicate the ledge of the windowsill.

The window becomes a frame within a frame, helping to enclose the space. This makes the scene more intimate and emphasizes the organic forms of the cat and the curtains.

EMPHASIZING THE SUBJECT

Adding dark values strengthens the structure of the geometric rectangles.

Light values and color changes contrast with the cat's neutral coat.

Cool colors surround the cat's body, which is surrounded by warm colors in the walls.

Blend to soften edges.

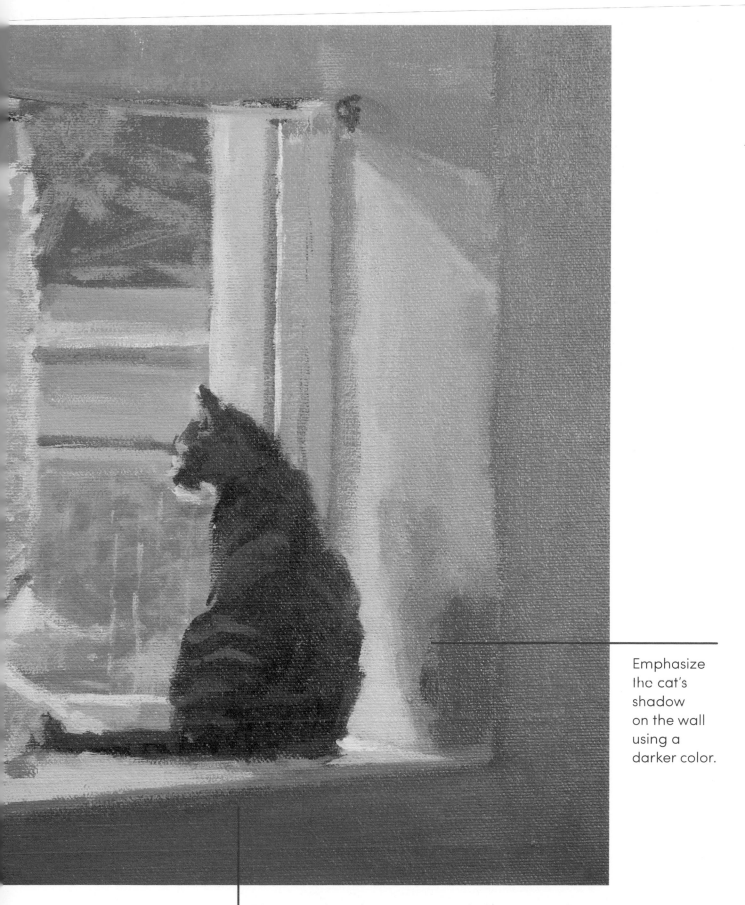

Emphasize the cat's shadow on the wall using a darker color.

The vertical window contrasts with the organic shape of the cat to emphasize the cat's upright form.

119

CREATING CLOSE-UPS

Simple subjects can make for beautiful paintings. Regardless of their skill level, all artists sometimes struggle to find the "perfect" subject for a painting. But there's no need to travel far and wide to find something—a bouquet of flowers can make a great subject for a simple still life like this one.

Apply a neutral, very diluted wash of random colors to a white canvas panel. An initial wash will air-dry quickly, but you can use a hair-dryer if you're in a hurry. Sketch the initial contour lines.

THIS PAINTING USES WARM AND COOL VARIETIES OF ALL THREE PRIMARY COLORS, PLUS A FEW EXTRAS, INCLUDING WHITE, VIOLET, GREEN, AND BLUE-GREEN.

Much of this painting can be done with a large flat brush. Block in the focal point of the painting—the largest flower—using four colors in an analogous color scheme (see page 27). Notice how the light yellow tints appear to project forward, while the relatively cool darker yellow and orange tones recede. This creates depth, dimension, and form.

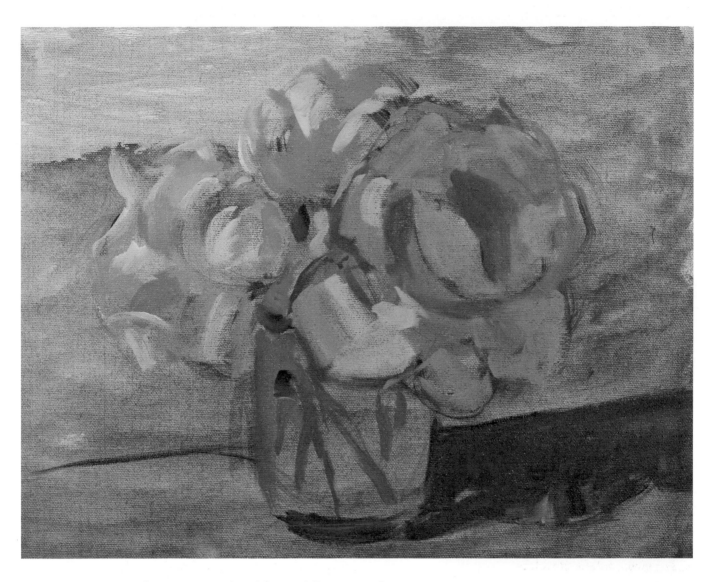

For the other two flowers, use the side and flat part of a medium-sized brush to paint on two value variations in neutral, cool colors. This makes the two flowers appear to recede behind the main flower. Midtone greens suggest stems in the glass.

tip

A SIZE 20 BRUSH WORKS WELL HERE.

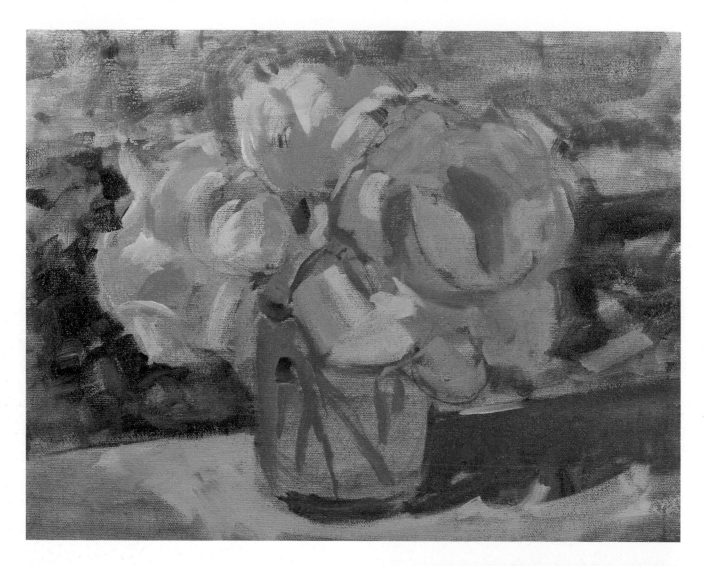

ANOTHER DIMENSION

Adding dark notes in the background creates depth by defining the flowers and pushing them forward. By painting flat values of light and dark on each side of the vase (on the tabletop), the vase looks supported. These values contrast with the more textured, dimensional forms of the flowers.

Add yellow tones that are lighter in value than any other part of the painting to create even greater dimension in the main flower.

Add more warm yellow notes to the main flower. You can layer color in patches, even layering over other patches of color.

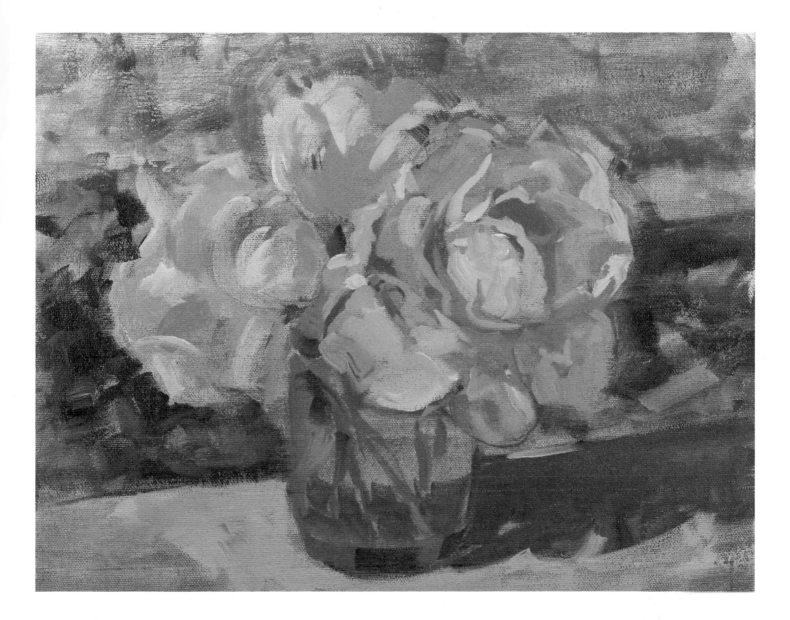

LAYERING COLORS BUILDS TEXTURE, FORM, AND DETAIL.

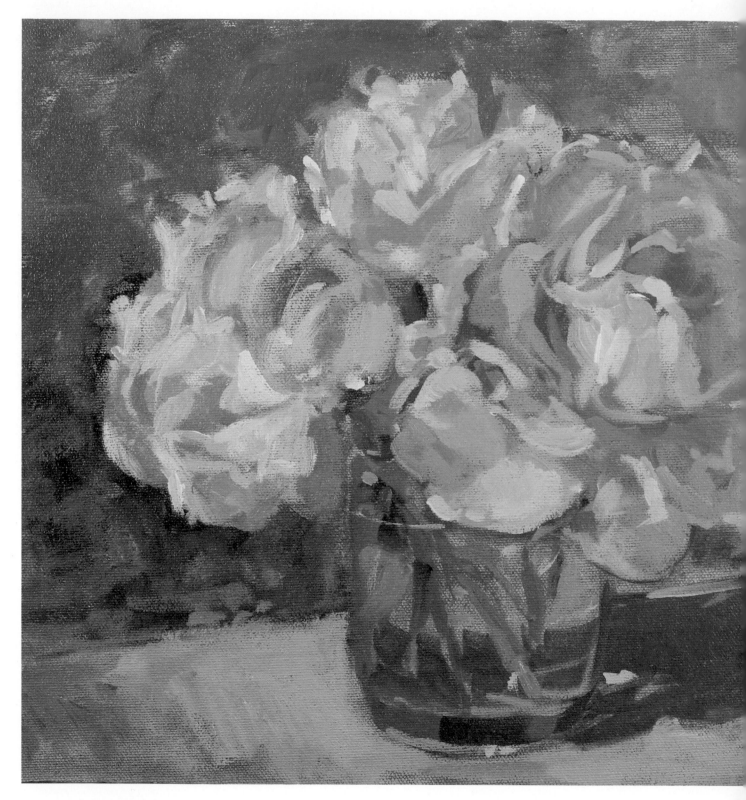

Add more brushwork and lighter values to the two white flowers, without pushing the contrasts between light and dark. This makes them appear subordinate to the main flower.

Use broken strokes to fill in the background on the left side, and allow some of the underpainting to show. To create visual interest, paint the left side of the background more red, and paint the right side darker green.

Add more paint to the tabletop to create the sense of a solid surface. Add some final touches, such as reflections, to the water glass and flower stems.

FINAL TOUCHES

Add a few additional bits of green and neutral tones to the left side of the main flower and to the glass to create more depth.

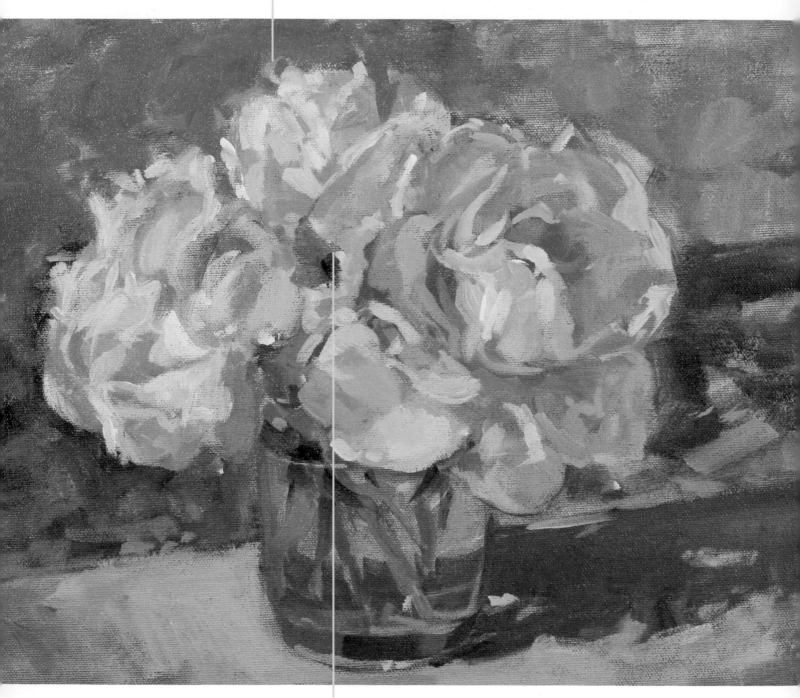

Notice the contrast in values.

Keep Painting!

Once you've looked through this book, I hope you are inspired to paint more frequently and to dig deeper into the world of creative expression. Daily sketches plus lots of hands-on practice will help you master acrylic painting. Paint your subjects again, and again, and again. Discover what works ... and what doesn't. Challenge yourself, and be a little daring. Take risks, and remember—just paint! This is the joy, the secret, and the power behind discovering creative expression and your authentic inner artist.

"TALENT COUNTS FOR MUCH, BUT EFFORT COUNTS FOR MORE"

—Carter Ratcliff, American art critic

About the Author

Susette Billedeaux Gertsch, MFA, developed her art career through painting experiences that include college and university education, public and private teaching, fieldwork, private sales, studio work, festivals, museum competitions, worldwide travels, and personal projects that span 40 years.

She taught school in Australia and Salt Lake City for 21 years, raised a family of 5 children, and retired from public teaching to focus on her professional painting career. She also initiated the founding of the Midway Art Association, which she presided over for 8 years and continues to be very involved with.

Susette competes in numerous plein air events in the western United States each year. She also maintains an active studio and online presence. Visit her at PleinAirParadise.com and iLove2Paint.com.